inGenius

A CRASH COURSE ON CREATIVITY

Tina Seelig

HarperOne
An Imprint of HarperCollinsPublishers

HarperOne

Grateful acknowledgment is given to the publishers for permission to reprint exerpts from the following copyrighted works:

Pages 15, 185, 190, 191, 193, 194, 195: Innovation Engines © Tina Seelig

Page 23: M. C. Escher's "Sky and Water I" © 2011 The M. C. Escher Company-Holland. All rights reserved. www.mcescher.com

Page 35, family dinner: Karen Sneider / *The New Yorker* Collection / www.cartoon bank.com

Page 35, hobby horse: Tom Cheney / *The New Yorker* Collection / www.cartoonbank.com

Page 61: Mind map © Paul Foreman, www.mindmapinspiration.com

Page 106: Adapted and reprinted with permission from "Creativity Under the Gun" by Teresa M. Amabile, Constance N. Hadley, and Steven J. Kramer. *Harvard Business Review,* August 2002.

HarperCollins books may be purchased for educational, business, or sales promotional use. For information please write: Special Markets Department, HarperCollins Publishers, 195 Broadway, New York, NY 10007.

HarperCollins website: http://www.harpercollins.com

HarperCollins®, ®, and HarperOne™ are trademarks of HarperCollins Publishers.

FIRST HARPERCOLLINS PAPERBACK EDITION PUBLISHED IN 2015

Designed by Level C

Library of Congress Cataloging-in-Publication Data
Seelig, Tina Lynn.
 inGenius : a crash course on creativity / Tina Seelig. — 1st ed.
 p. cm.
 ISBN 978-0-06-202071-0
 1. Creative thinking. 2. Creative ability. 3. Creative ability in business. I. Title.
 BF408.S865 2012
 153.3'5—dc23 2011044579

15 16 17 18 19 RRD(H) 10 9 8 7 6 5 4 3 2 1

"*inGenius* is a fascinating blueprint for any company that's serious about creating an environment where new ideas can thrive, and many of Seelig's students doubtless go on to do precisely that."

—*Fortune Magazine*

"Seelig demonstrates that creativity and experimentation are both personal mindsets and values in organizations. *inGenius* acts as a spark plug for managers and entrepreneurs who want to capitalize on the creativity in their organizations."

—*Library Journal*

"Many of us believe that we're either born with creativity or we're not, and that this 'gift' cannot be taught or fostered. Tina Seelig, author of *inGenius: A Crash Course on Creativity*, and award-winning educator at Stanford University, says that's wrong: Creativity can be easily taught and learned."

—*USA Weekend*

"Seelig is a sharp observer and a gentle and thoughtful writer."

—*Miami Herald*

"Tina invites us inside her Stanford University course to reveal that we all have creative potential waiting to be unleashed."

—Ori Brafman, coauthor of *Sway* and *Click*

"In a world that's in constant flux, creativity and innovation are essential qualities for successful executives and industry-leading companies. Tina Seelig has shown that we all have the ability to mobilize our creative spirit."

—Chip Conley, founder of Joie de Vivre Hospitality and author of *Emotional Equations*

"Who said creativity can't be taught? It can, and Tina Seelig has done it! She has created a new model, the Innovation Engine, that will change the way you think."

—Steve Blank, entreprenuer and author of *The Startup Owner's Manual*

"In this groundbreaking work, Tina Seelig has codified her years of teaching at Stanford and proves that anyone can be creative."

—Nancy Duarte, CEO of Duarte and author of *Resonate*

"Tina Seelig has shattered the misconception that you can't increase creativity. In this book, she presents breakthrough ideas on how to understand and boost your ability to innovate."

—Guy Kawasaki, author of *Enchantment* and former chief evangelist of Apple

"Tina Seelig has written a provocative field guide to twenty-first-century creativity, with her energy and enthusiasm bursting through on every page. We all could use a little extra spark of creativity, and this book helps show the way."

—Tom Kelley, general manager of IDEO and author of *The Art of Innovation*

"Few people have done as much to champion innovative thinking as Tina Seelig."

—David Kelley, founder of IDEO

"Tina Seelig is one of the most creative and inspiring teachers at Stanford."

—Robert Sutton, Stanford University professor and author of *The No Asshole Rule*

"Tina is the most inspirational creativity voice I know."

—Geoffrey Moore, author of *Crossing the Chasm* and *Dealing with Darwin*

"Tina Seelig has written a powerful and practical book, jam-packed with keen insights for unleashing creativity in yourself and others."

—Peter Sims, author of *Little Bets: How Breakthrough Ideas Emerge from Small Discoveries*

For sweet Sylvine

CONTENTS

INTRODUCTION

IDEAS AREN'T CHEAP— THEY'RE FREE

Provocative. Just one word . . . provocative.

Until recently, prospective students at All Soul's College, at Oxford University, took a "one-word exam." The Essay, as it was called, was both anticipated and feared by applicants. They each flipped over a piece of paper at the same time to reveal a single word. The word might have been "innocence" or "miracles" or "water" or "provocative." Their challenge was to craft an essay in three hours inspired by that single word.

There were no right answers to this exam. However, each applicant's response provided insights into the student's wealth of knowledge and ability to generate creative connections. The *New York Times* quotes one Oxford professor as saying, "The unveiling of the word was once an event of such excitement that even nonapplicants reportedly gathered outside the college each year, waiting for news to waft out."[1] This challenge reinforces the fact that everything—*every single word*—provides an opportunity to leverage what you know to stretch your imagination.

For so many of us, this type of creativity hasn't been fostered. We don't look at everything in our environment as an opportunity for ingenuity. In fact, creativity should be an imperative.

Creativity allows you to thrive in an ever changing world and unlocks a universe of possibilities. With enhanced creativity, instead of problems you see potential, instead of obstacles you see opportunities, and instead of challenges you see a chance to create breakthrough solutions. Look around and it becomes clear that the innovators among us are the ones succeeding in every arena, from science and technology to education and the arts. Nevertheless, creative problem solving is rarely taught in school, or even considered a skill you can learn.

Sadly, there is also a common and often-repeated saying, "Ideas are cheap." This statement discounts the value of creativity and is utterly wrong. Ideas aren't cheap at all—they're free. And they're amazingly valuable. Ideas lead to innovations that fuel the economies of the world, and they prevent our lives from becoming repetitive and stagnant. They are the cranes that pull us out of well-worn ruts and put us on a path toward progress. Without creativity we are not just condemned to a life of repetition, but to a life that slips backward. In fact, the biggest failures of our lives are not those of execution, but failures of imagination. As the renowned American inventor Alan Kay famously said, "The best way to predict the future is to invent it." We are all inventors of our own future. And creativity is at the heart of invention.

As demonstrated so beautifully by the "one-word exam," every utterance, every object, every decision, and every action is an opportunity for creativity. This challenge, one of many tests given over several days at All Soul's College, has been called the hardest exam in the world. It required both a breadth of knowledge and a healthy dose of imagination. Matthew Edward Harris, who took the exam in 2007, was assigned the word "harmony." He wrote in the *Daily Telegraph* that he felt "like a chef rummaging through the recesses of his refrigerator for unlikely soup in-

gredients."[2] This homey simile is a wonderful reminder that these are skills that we have an opportunity to call upon every day as we face challenges as simple as making soup and as monumental as solving the massive problems that face the world.

I teach a course on creativity and innovation at the Hasso Plattner Institute of Design, affectionately called the "d.school,"[3] at Stanford University. This complements my full-time job as executive director of the Stanford Technology Ventures Program (STVP),[4] in the Stanford School of Engineering. At STVP our mission is to provide students in all fields with the knowledge, skills, and attitudes needed to seize opportunities and creatively solve major world problems.

On the first day of class, we start with a very simple challenge: redesigning a name tag. I tell the students that I don't like name tags at all. The text is too small to read. They don't include the information I want to know. And they're often hanging around the wearer's belt buckle, which is really awkward. The students laugh when they realize that they too have been frustrated by the same problems.

Within fifteen minutes the class has replaced the name tags hanging around their necks with beautifully decorated pieces of paper with their names in large text. And the new name tags are pinned neatly to their shirts. They're pleased they have successfully solved the problem and are ready to go on to the next one. But I have something else in mind. . . . I collect all of the new name tags and put them in the shredder. The students look at me as though I have gone nuts!

I then ask, "Why do we use name tags at all?" At first, the students think that this is a preposterous question. Isn't the answer

obvious? Of course, we use name tags so that others can see our name. They quickly realize, however, that they've never thought about this question. After a short discussion, the students acknowledge that name tags serve a sophisticated set of functions, including stimulating conversations between people who don't know each other, helping to avoid the embarrassment of forgetting someone's name, and allowing you to quickly learn about the person with whom you are talking.

With this expanded appreciation for the role of a name tag, students interview one another to learn how they want to engage with new people and how they want others to engage with them. These interviews provide fresh insights that lead them to create inventive new solutions that push beyond the limitations of a traditional name tag.

One team broke free from the size constraints of a tiny name tag and designed custom T-shirts with a mix of information about the wearer in both words and pictures. Featured were the places they had lived, the sports they played, their favorite music, and members of their families. They vastly expanded the concept of a "name tag." Instead of wearing a tiny tag on their shirts, each shirt literally became a name tag, offering lots of topics to explore.

Another team realized that when you meet someone new, it would be helpful to have relevant information about that person fed to you on an as-needed basis to help keep the conversation going and to avoid embarrassing silences. They mocked up an earpiece that whispers information about the person with whom you are talking. It discreetly reveals helpful facts, such as how to pronounce the person's name, his or her place of employment, and the names of mutual friends.

Yet another team realized that in order to facilitate meaningful connections between people, it is often more important to

know how the other person is feeling than it is to know a collection of facts about them. They designed a set of colored bracelets, each of which denotes a different mood. For example, a green ribbon means that you feel cheerful, a blue ribbon that you are melancholy, a red ribbon that you're stressed, and a purple ribbon that you feel fortunate. By combining the different colored ribbons, a wide range of emotions can be quickly communicated to others, facilitating a more meaningful first connection.

This assignment is designed to demonstrate an important point: there are opportunities for creative problem solving everywhere. Anything in the world can inspire ingenious ideas—even a simple name tag. Take a look around your office, your classroom, your bedroom, or your backyard. *Everything* you see is ripe for innovation.

Creativity is an endless renewable resource, and we can tap into it at any time. As children we naturally draw upon our imagination and curiosity in an attempt to make sense of the complicated world around us. We experiment with everything in our midst, dropping things to see how far they fall, banging things to see how they sound, and touching all the things we can get our hands on to see how they feel. We mix together random ingredients in the kitchen to see how they taste, make up games with our friends, and imagine what it would be like to live on other planets. Essentially, we have both creative competence and confidence; and the adults around us encourage our creative endeavors, building environments that tickle our imagination.

As we approach adulthood, we are expected to be serious, to work hard, and to be "productive." There is an ever increasing emphasis on planning and preparing for the future rather than

experimenting and exploring in the present, and the spaces in which we work reflect this new focus. With this type of external pressure and messaging, we shut down our natural curiosity and creativity as we strive to deliver what is expected of us. We give up on playing and focus on producing, and we trade in our rich imagination in order to focus on implementation. Our attitude changes and our creative aptitude withers, as we learn to judge and dismiss new ideas.

The great news is that our brains are built for creative problem solving, and it is easy to both uncover and enhance our natural inventiveness. The human brain evolved over millions of years from a small collection of nerve cells with limited functionality to a fabulously complex organ that is optimized for innovation. Our highly developed brains are always assessing our ever changing environment, mixing and matching our responses to fit each situation. Every sentence we craft is unique, each interaction we have is distinctive, and every decision we make is done with our own free will. That we have the ability to come up with an endless set of novel responses to the world around us is a constant reminder that we are born to be inventive.

Nobel Prize–winning neuroscientist Eric Kandel says that the brain is a creativity machine.[5] It appears that the quantity and diversity of our ideas are mediated by the frontal lobes, right behind your forehead. Preliminary brain research by Charles Limb at Johns Hopkins University shows that the parts of your brain that are responsible for self-monitoring are literally turned off during creative endeavors. He uses functional magnetic resonance imaging (MRI), which measures metabolic activity in the different areas of the brain, to study brain activity in jazz musicians and rap artists. While they are in the MRI scanner, he asks the musicians to compose an improvisational piece of music.

While they are playing, Limb has found that a part of the brain's frontal lobes believed to be responsible for judgment shows much lower activity.[6] This implies that during this creative process the brain actively shuts off its normal inhibition of new ideas. For many activities it is important to have high self-monitoring of your behavior so that you don't say everything you think or do everything that you consider. But when you are generating new ideas, this function gets in the way. Creative people have apparently mastered the art of turning off this part of their brains to let their ideas flow more smoothly, unleashing their imagination.

The title of this book, *inGenius*, reflects the fact that we each have creative genius waiting to be unlocked. The word "ingenious" is derived from the Latin term *ingenium*, which means natural capacity or innate talent. For centuries people have questioned these natural talents and looked outside themselves for the source of creative inspiration. The ancient Greeks believed there were goddesses, called Muses, who inspired literature and art, and they worshipped them for their powers.[7] Later, in Elizabethan England, William Shakespeare invoked his muse when writing sonnets, often beseeching her for help.[8] Ideas often feel inspired and, therefore, it made sense to beseech a muse for inspiration. However, we now know that it is really up to you to ignite your inborn inventiveness.

Many people question whether creativity can be taught and learned. They believe that creative abilities are fixed, like eye color, and can't be changed. They think that if they aren't currently creative, there is no way to increase their ability to come up with innovative ideas. I couldn't disagree more. There is a concrete set of methods and environmental factors that can be used to enhance your imagination, and by optimizing these variables your creativity naturally increases. Unfortunately, these tools are

rarely presented in a formalized way. As a result, creativity appears to most people to be something magical rather than the natural result of a clear set of processes and conditions.

It might seem counterintuitive to use a set of tools to enhance creativity, since creativity necessitates doing things that haven't been done before. But a guide is just what we need. Just as scientists adopt tried-and-true scientific methods to design experiments, enhancing your creativity benefits from a formal set of tools for idea generation. Consider the fact that we are taught how to use the scientific method from the time we are children. Starting at an early age, we learn how to make hypotheses and to test them in order to discover how the world in which we live works. We learn how to ask probing questions, to unpack all the assumptions, and to design experiments to reveal the answers. This important skill and the associated vocabulary are honed for years until they become quite natural.

The scientific method is clearly invaluable when you are trying to unlock the mysteries of the world. However, you need a complementary set of tools and techniques—*creative thinking*—when you want to *invent* rather than *discover*. These two endeavors are completely different, but they work in concert. Like the scientific method, creative thinking uses well-defined tools, demystifies the pathway for invention, and provides a valuable framework for creating something new. Successful scientists and innovators in all fields move back and forth between discovery and invention, using both scientific and creative thinking processes. In fact, most great scientists are also accomplished inventors who pose the most innovative questions and invent ingenious methods to test their scientific theories. It is time to make creative thinking, just like the scientific method, a core part of our education from the time we are children, and to reinforce these lessons throughout our lives.

We already use creative thinking to some degree when we face challenges in all aspects of our lives. Some of these challenges result in quick creative fixes, such as using a shoe to prop open a door, folding over the corner of a page to mark where you left off reading, or using replacements for ingredients you don't have when making dinner. These solutions come so naturally that we don't even think of them as innovative responses to the small problems that surface each day. However, other creative solutions are significant enough to grow into entire industries. Everything we use has been conceived of and invented by someone, including alarm clocks, buttons, card games, cell phones, commercials, condoms, diapers, doorknobs, eyeglasses, food processors, garage sales, hairbrushes, the Internet, jackets, jet engines, kites, lasers, matches, measuring cups, movie theaters, nail files, paper clips, pencils, picture frames, radios, rubber bands, socks, toasters, toothbrushes, umbrellas, wineglasses, and zippers. All of these inventions resulted when individuals were faced with a problem or saw an opportunity and created a way to bring their innovation to the world.

There are always problems to be solved, improvements to be made, and breakthrough products to be invented. Every new venture begins by addressing a problem or responding to an opportunity and relies upon the creativity of the founders. However, just like individuals, most organizations curb their creative tendencies as they mature, locking down their products and processes, and focusing on execution rather than imagination. Like muscles that atrophy from lack of use, innovation shrivels up when ignored. This is terribly unfortunate. By blindly moving ahead, individuals and organizations fall farther and farther behind those who are able to creatively adapt to the ever changing environment.

Innovative firms know that it is critically important to have people on their teams who can creatively respond to unanticipated challenges. For example, at Google recruiters ask prospective employees questions that test their expertise in the domain in which they will be working, such as software or marketing, as well as questions that require creative thinking. They might ask, "How many golf balls would fit in a school bus?" "How many piano tuners are there in the entire world?" or "Imagine that you are shrunk to the height of a nickel and are then thrown into an empty glass blender. The blades will start moving in sixty seconds. What do you do?" These questions are designed to identify individuals who can solve problems that do not have one correct answer.

A number of scientists have tried to formalize a measurement of creativity and have devised tests to calculate your "creativity quotient," or CQ. For example, they might look at the number of diverse ideas you generate when given a specific challenge, such as how many things you can do with a single paper clip, a postage stamp, a brick, or a piece of paper. They believe that just as your intelligence quotient (IQ) is a rough measure of your intelligence, this type of measurement is a useful way to evaluate your creativity.[9] In these types of tests, some people come up with a few obvious answers, while others generate endless lists of uses for these simple objects. It is assumed that the longer and more diverse your list of uses for a paper clip or a piece of paper, the more likely you are to come up with creative solutions to real-world challenges.

From my perspective, this is a fun warm-up exercise, much like stretching before performing a complex gymnastics routine. It is much too simplistic, however, if your goal is to determine whether someone is going to generate creative solutions to real-world problems. In a gymnastics competition, for instance, there is a long list of variables that determine your ability to perform,

including your training, your motivation to perform well, and the equipment you are using. Creativity, like gymnastics, is quite complex and is influenced by many factors, such as your knowledge, motivation, and environment. These variables are just as important in determining your creativity as your ability to make a list of things you can do with a paper clip or to shimmy out of a blender. In addition, creativity is a quality not only of individuals, but also of groups, organizations, and entire communities. Therefore, it makes sense to consider all the variables that influence ingenuity, including individual skills and how the environment influences them.

My course on creativity is designed to teach students to look at a wide range of factors—both inside themselves and in the outside world—that affect ingenuity. We use many techniques, including workshops, case studies, design projects, simulation games, field trips, and visits from experts who work in highly innovative ventures. Students learn how to polish their powers of observation, practice connecting and combining ideas, and train themselves to challenge their assumptions and reframe problems. They leave with a set of creative-thinking tools that facilitate the generation of fresh ideas.

During the course, students tackle several different projects, each of which is crafted to focus on another aspect of the creative-thinking process. They work in interdisciplinary teams that include students from engineering, science, law, education, business, and the arts. This multidisciplinary approach is critical, since most problems we face today require input and insights from those with different backgrounds and perspectives.

Students also get exposure to an array of environments that foster creativity and learn how to build ventures that are optimized for innovation. We focus on the variables they have

at their disposal to enhance creativity in groups, including re-designing the physical space, changing the rules, and modifying the incentives across the organization. We visit a range of companies to see how their environments influence innovation, and students get a chance to interact with the leaders of these firms to learn how they institute practices to enhance creative output.

After a dozen years teaching courses on creativity and innovation, I can confidently assert that creativity can be enhanced. The following chapters are filled with details about specific tools and techniques that work well, along with stories that bring them to life. We will look at ways to increase your ability to see opportunities around you, to connect and combine ideas, to challenge assumptions, and to reframe problems. We will explore ways you can modify your physical and social environment to enhance your creativity and the creativity of those with whom you live and work. In addition, we will look at the ways your motivation and mind-set influence your creative output, including your willingness to experiment, your ability to push through barriers to find creative solutions to daunting challenges, and your skill at turning off premature judgment of new ideas.

It is important to understand that these factors fit together and profoundly influence one another. Therefore, none can be viewed in isolation. I've created a new model—the Innovation Engine—shown below, that illustrates how all these factors work together to enhance creativity. I chose the word "engine" because it, like the word "ingenious," is derived from the Latin word for innate talent and is a reminder that these traits come naturally to all of us. My goal is to provide a model, a shared vocabulary, and a set of tools that you can use right away to evaluate and increase your own creativity and that of your team, organization, and community.

INNOVATION ENGINE

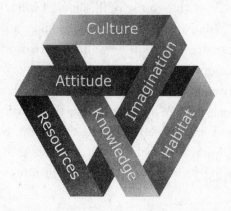

The three parts on the inside of your Innovation Engine are *knowledge, imagination,* and *attitude:*

- Your *knowledge* provides the fuel for your imagination.

- Your *imagination* is the catalyst for the transformation of knowledge into new ideas.

- Your *attitude* is a spark that sets the Innovation Engine in motion.

The three parts on the outside of your Innovation Engine are *resources, habitat,* and *culture.*

- *Resources* are all the assets in your community.

- *Habitats* are your local environments, including your home, school, or office.

- *Culture* is the collective beliefs, values, and behaviors in your community.

Like creativity, at first glance the Innovation Engine might look complex. Over the course of this book, I will take apart the Innovation Engine and examine its six components. I will then put it back together and show how all the parts work in concert and influence one another to enhance creativity. You will find that the Innovation Engine snaps into focus as we explore each of the components and see how they fit together. I will concentrate on the parts of the Innovation Engine that you directly control: imagination, knowledge, habitat, and attitude. And you will see that you can set your Innovation Engine in motion in myriad ways.

Chapters 1 to 3 delve into the process of enhancing your *imagination* by reframing problems, connecting ideas, and challenging assumptions. Chapter 4 focuses on building your base of *knowledge* by polishing your powers of observation. Chapters 5 to 8 investigate the factors in your *habitat* that influence your creativity, including space, constraints, incentives, and team dynamics. Chapters 9 and 10 address your *attitude* by looking closely at your willingness to experiment and your ability to push through challenges to solve problems that seem insurmountable. And chapter 11 pulls the components back together and shows how all the parts fit together to create a powerful engine for innovation.

There is a recurring theme: creativity is not just something you think about—it is something you *do*. In the following chapters, you will learn how to jump-start your Innovation Engine, and you will fully appreciate that every word, every object, every idea, and every moment provides an opportunity for creativity. It costs nothing to generate amazing ideas, and the results are priceless.

ONE

SPARK A REVOLUTION

W hat is the sum of 5 plus 5?"
"What two numbers add up to 10?"

The first question has only one right answer, and the second question has an infinite number of solutions, including negative numbers and fractions. These two problems, which rely on simple addition, differ only in the way they are framed. In fact, all questions are the frame into which the answers fall. And as you can see, by changing the frame, you dramatically change the range of possible solutions. Albert Einstein is quoted as saying, "If I had an hour to solve a problem and my life depended on the solution, I would spend the first fifty-five minutes determining the proper question to ask, for once I know the proper question, I could solve the problem in less than five minutes."

Mastering the ability to reframe problems is an important tool for increasing your imagination because it unlocks a vast array of solutions. With experience it becomes quite natural. Taking photos is a great way to practice this skill. When Forrest Glick, an avid photographer, ran a photography workshop near Fallen Leaf Lake in California, he showed the participants how to see the scene from many different points of view, framing and

reframing their shots each time. He asked them to take a wide-angle picture to capture the entire scene, then to take a photo of the trees close to shore. Forrest then asked them to bring the focus closer and closer, taking pictures of a single wildflower, or a ladybug on that flower. He pointed out that you can change your perspective without even moving your feet. By just shifting your field of view up or down, or panning left or right, you can completely change the image. Of course, if you walk to the other side of the lake, climb up to the top of one of the peaks, or take a boat onto the water, you shift the frame even more.

A classic example of this type of reframing comes from the stunning 1968 documentary film *Powers of Ten,* written and directed by Ray and Charles Eames. The film, which can be seen online, depicts the known universe in factors of ten:

> Starting at a picnic by the lakeside in Chicago, this famous film transports us to the outer edges of the universe. Every ten seconds we view the starting point from ten times farther out until our own galaxy is visible only as a speck of light among many others. Returning to earth with breathtaking speed, we move inward—into the hand of the sleeping picnicker—with ten times more magnification every ten seconds. Our journey ends inside a proton of a carbon atom within a DNA molecule in a white blood cell.[1]

This magnificent example reinforces the fact that you can look at every situation in the world from different angles, from close up, from far away, from upside down, and from behind. We are creating frames for what we see, hear, and experience all day long,

and those frames both inform and limit the way we think. In most cases, we don't even consider the frames—we just assume we are looking at the world with the proper set of lenses. However, being able to question and shift your frame of reference is an important key to enhancing your imagination because it reveals completely different insights. This can also be accomplished by looking at each situation from different individuals' points of view. For example, how would a child or a senior see the situation? What about an expert or a novice, or a local inhabitant versus a visitor? A wealthy person or a poor one? A tall person or a short one? Each angle provides a different perspective and unleashes new insights and ideas.

At the Stanford d.school, students are taught how to empathize with very different types of people, so that they can design products and experiences that match their specific needs. When you empathize, you are, essentially, changing your frame of reference by shifting your perspective to that of the other person. Instead of looking at a problem from your own point of view, you look at it from the point of view of your user. For example, if you are designing anything, from a lunch box to a lunar landing module, you soon discover that different people have very diverse desires and requirements. Students are taught how to uncover these needs by observing, listening, and interviewing and then pulling their insights together to paint a detailed picture from each user's point of view.

Another valuable way to open the frame when you are solving a problem is to ask questions that start with "why." In his need-finding class, Michael Barry uses the following example: If I asked you to build a bridge for me, you could go off and build a bridge. Or you could come back to me with another question:

"*Why* do you need a bridge?" I would likely tell you that I need a bridge to get to the other side of a river. Aha! This response opens up the frame of possible solutions. There are clearly many ways to get across a river besides using a bridge. You could dig a tunnel, take a ferry, paddle a canoe, use a zip line, or fly a hot-air balloon, to name a few.

You can open the frame even farther by asking *why* I want to get to the other side of the river. Imagine I told you that I work on the other side. This, again, provides valuable information and broadens the range of possible solutions even more. There are probably viable ways for me to earn a living without ever going across the river.

The simple process of asking "why" questions provides an incredibly useful tool for expanding the landscape of solutions for a problem. The story in the introduction of this book, on name tags, reinforces this concept. When I asked *why* we use name tags, the scope of solutions expanded exponentially.

Being able to look at situations using different frames is critically important when tackling all types of challenges. Consider the fact that before 1543 people believed that the sun and all the planets revolve around the earth. To all those who looked to the sky, it seemed obvious that the earth was the center of the universe. But in 1543, Copernicus changed all of that by proposing that the sun is actually at the center of the solar system. This was a radical change in perspective—or frame—that resulted in what we now call the Copernican Revolution. This shift in point of view, in which the earth is seen as but one of many planets circling the sun, dramatically changed the way individuals thought about the universe and their individual roles within it. It opened

up the world of astronomy and provided a new platform for inquiry. You, too, can spark a revolution by looking at the problems you face from different perspectives.

Some artists and musicians specialize in shifting our frame of reference to encourage us to see the world with fresh eyes. M. C. Escher, for example, is famous for graphic art in which he plays with perception, challenging us to see the foreground as the background and vice versa. In one of his famous works, the foreground and background consist of fish and birds. As you view the image from top to bottom, the birds in the foreground recede into the background as the fish in the background emerge.

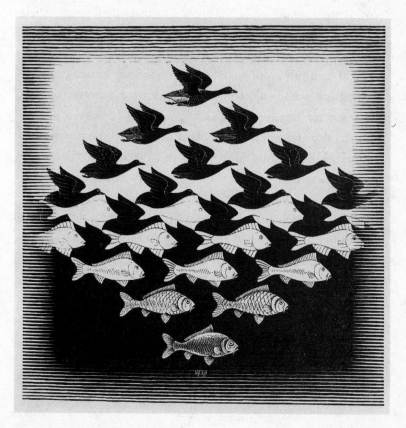

Another example comes from the composer John Cage, who created a work called *4'33"* (pronounced "four minutes, thirty-three seconds"). It was composed in 1952 for any instrument or combination of instruments. The score instructs the performers to sit quietly, *not* playing their instruments for the entire duration of the piece. The goal is for the audience to focus on the ambient sounds in the auditorium rather than performed music. This controversial piece is provocative in that it shifts our attention to the sounds with which we are surrounded all the time.

Another musical example involves the renowned violinist Joshua Bell. He normally plays to packed houses of patrons who pay hundreds of dollars to see him perform. In 2007, *Washington Post* columnist Gene Weingarten asked Bell to play in the Metro subway station in Washington, D.C., to see how people would respond to him in a different context. He was dressed casually, wearing a baseball cap, while he played a magnificent piece of music on his Stradivarius violin. Weingarten placed a hidden camera in the station to watch the response of those who passed by. Among the 1,097 people who saw Bell that day, only 7 stopped to listen, despite the fact that he was playing the same music he plays on stage. For his forty-five-minute performance, Bell earned only $32.17 in tips, including $20 from someone who recognized him. When he performed in this unconventional context, and the audience was not seated in an auditorium, despite the beauty of his music, listeners barely noticed his existence. In these new frames, passersby didn't see Bell in the same light that they saw him when illuminated on stage.[2]

We can practice shifting frames every day. For instance, turn a rock or piece of driftwood into art by placing it on display. Look at the young assistant in your office as a future CEO. Or, sit on the floor to see how a young child sees the world. Another way

to shake up your frame of reference is to change your environment altogether. A wonderful example is described by Derek Sivers, founder of CD Baby, in his TED talk called "Weird, or Just Different?" He describes the way cities in Japan are organized. Instead of naming the streets and numbering the buildings as we do in the United States, in Japan the city blocks are numbered. The streets are seen as the spaces in between the blocks. In addition, on each block buildings are numbered in the order of when they were constructed rather than where they are located.[3] This appears to be intuitive for those who have grown up in the neighborhood and have watched all the buildings go up over time. This example points to the fact that the way we do most things is arbitrary. It is up to you to see the discretionary nature of many of your choices and to find a way to shift your point of view so that you can uncover alternative approaches.

We make the mistake of assuming that the way we do things is the one right way. For example, we believe that specific types of clothing are appropriate for different occasions, we have preconceived ideas about how to greet someone, and we have fixed ideas about what should be eaten at each meal of the day. However, a quick trip to China, Mexico, Pakistan, or Korea reveals completely different norms in all of these areas. If you go to a restaurant for breakfast in China, for instance, you will be served rice porridge flavored with shrimp or "thousand-year-old" eggs; in Mexico you might be served an omelet with *huitlacoche*, a delicacy made from corn smut; in Pakistan you could get soup made from the head and feet of a goat; and in Korea you will certainly be served fermented vegetables.

On the topic of food, some innovative chefs are completely reframing what a restaurant is and what it could be. Instead of places that will attract customers for a long time and build a loyal

following, some chefs are setting up "pop-up" restaurants that are designed to exist for a short period of time and then disappear. These flash restaurants are more like theater performances.[4] This reframing shifts the possibilities for restaurant decor, menu, serving staff, and advertising strategy.

This type of thinking can be applied to any industry anywhere in the world. For example, the directors of the Tesco food-marketing business in South Korea set a goal to increase market share substantially and needed to find a creative way to do so. They looked at their customers and realized that their lives are so busy that it is actually quite stressful to find time to go to the store. So they decided to bring their store to the shoppers. They completely reframed the shopping experience by taking photos of the food aisles and putting up full-sized images in the subway stations. People can literally shop while they wait for the train, using their smartphones to buy items via photos of the QR codes and paying by credit card. The items are then delivered to them when they get home. This new approach to shopping boosted Tesco's sales significantly.[5]

Reframing problems is not a luxury. On the contrary, all companies need to continually reframe their businesses in order to survive as the market and technology change. For example, Kodak defined its business as making cameras and film. When digital cameras made film photography obsolete, the company lost out badly, because it wasn't able to open its frame early enough to see its business as including this new technology. On the other hand, Netflix began delivering DVDs of movies by mail. It framed its goals much more broadly, however, seeing itself as in the movie-delivery business, not just the DVD-delivery business. When technology allowed online delivery of movies, it

was poised to dominate in this new arena, too. We are also seeing the same thing happen with books. Amazon was originally set up to deliver hard copies of books, but it has enthusiastically reframed its business and embraced the sale of electronic books, and even designed its own digital book reader.

Framing and reframing of problems also opens up the door to innovative new ventures. Scott Summit, the founder of Bespoke, created a brand-new way to envision prosthetics for people who have lost a limb.[6] The word "bespoke" comes from Old English and means "custom-tailored." That is exactly what his company does: it makes custom-tailored limbs for those who have lost them. Scott's biggest insight was that some people with artificial limbs are embarrassed by their disability and want to hide their unsightly artificial limbs as much as possible. He reframed the problem by looking at an artificial limb not just as a functional medical device, but as a fashion accessory. Essentially, he decided to make prosthetics that are *cooler* than normal limbs.

Bespoke makes its customized limbs using a brand-new technique for 3D printing. Its designers first do a 3D scan of the surviving limb to make sure that the new limb is completely symmetrical with the surviving one. After they print the new limb, they cover it with materials that match the user's lifestyle. For example, a new leg can be designed to look like a leather cowboy boot, or it can be covered in brushed chrome to match the user's motorcycle, or it can be cut out to look like lace to match a fashionable dress. Not only is the leg functional, but the wearer is actually proud to display it publicly. Essentially, the prosthetic was transformed from a medical device into a fashion statement.

Innovative educators are also reframing what it means to be a teacher and to be a student. In a standard history class, for example, students are traditionally given textbooks that are filled with facts and dates, and they are charged with memorizing the information. But if you step back and reconsider the goal, you might design the classroom experience completely differently. This is exactly what was done in the San Francisco Unified School District. Faculty from the Stanford University School of Education designed a brand-new history curriculum that dramatically changes the students' point of view. Instead of being passive students, they become active historians.

According to Deborah Stipek, the dean of the School of Education at Stanford, instead of textbooks, high-school students are now given original sources to study, such as copies of letters from a wide range of people who lived during the period being studied, historical maps of the region, and local newspaper articles that covered the story from different perspectives. In the new "Reading like a Historian" project, led by Abby Reisman and Sam Wineburg, the students get to study the information from all different points of view and come up with their own opinion about what really happened during that period. They discuss and debate the issues with their classmates. Not only does this approach provide a much deeper understanding of the material, but the students also make insightful connections and discoveries, which propels them to discover even more.[7]

When evaluated on the mastery of the factual material, the students in the history classes that used original sources did better than those who were in standard classes using textbooks. Beyond the test scores, there were many other benefits. These students were more engaged and much more enthusiastic about

history. They viewed themselves as historical investigators and gained critical-thinking skills that they would never have learned had they merely memorized a list of facts. By redesigning the way history is taught, giving students diverse and often contradictory information, we help students learn how to look at the world with different frames of reference.

There are some entertaining ways to practice changing your perspective. One of my favorites is to analyze jokes. Most are funny because they change the frame of the story when we least expect it. Here is an example:

> Two men are playing golf on a lovely day. As the first man is about to tee off, a funeral procession goes by in the cemetery next door. He stops, takes off his hat, and bows his head.
>
> The second man says, "Wow, you are incredibly thoughtful."
>
> The first man says, "It's the least I could do. She and I were married for twenty-five years."

As you can see, the frame shifts in the last line. At first the golfer appears thoughtful, but he instantly turns into a jerk when you learn that the deceased person was his wife.

Another classic example comes from one of the Pink Panther movies:

INSPECTOR CLOUSEAU: Does your dog bite?
HOTEL CLERK: No.

CLOUSEAU: [bowing down to pet the dog] Nice doggie.
[The dog bites Clouseau's hand.]
CLOUSEAU: I thought you said your dog did not bite!
HOTEL CLERK: That is not my dog.

Again, the frame shifts at the end of the joke when you realize they are talking about two different dogs. Take a careful look at jokes, and you will find that the creativity and humor usually come from shifting the frame.

Reframing problems takes effort, attention, and practice, and allows you to see the world around you in a brand-new light. You can practice reframing by physically or mentally changing your point of view, by seeing the world from others' perspectives, and by asking questions that begin with "why." Together, these approaches enhance your ability to generate imaginative responses to the problems that come your way.

TWO

BRING IN THE BEES

What happens when you cross a checkerboard with a midnight snack? You get edible checkers, sold with the motto "Beat 'em and Eat 'em." What if you cross high-heeled shoes with a tricycle? You get pumps with training wheels. Or, what do you get when you cross a dessert plate with an ice-cube tray? An ice cream bowl that melts after use so you don't have to wash it.

These are just a few of the wonderfully fanciful ideas in John Cassidy and Brendan Boyle's *The Klutz Book of Inventions*. The goal of their book is to help readers become comfortable creating ridiculous ideas, since many brilliant ideas seem really crazy when they are initially conceived.[1] The playful inventions they describe result from connecting and combining objects and concepts that on the surface seem unrelated. By exploring ways to fuse them together, we see many surprising and interesting ideas surface.

This is similar to the philosophy behind the Japanese art of *chindōgu*, which involves coming up with "unuseless" inventions. Essentially, *chindōgu* involves combining products that are completely unrelated to create inventions that are wonderfully unusual. For example, an outfit worn by a baby with a mop on

its belly that allows the baby to clean the floor while crawling around; a shirt with a matrix on the back, so that you can tell someone exactly where to scratch; an upside-down umbrella that allows you to collect water when you are walking in the rain; or eyeglasses with arms that can be removed to be used as chopsticks. These inventions might not be immediately practical, but each one opens a door to new ideas that just might be.

Being able to connect and combine nonobvious ideas and objects is essential for innovation and a key part of the creative-thinking process. Along with your ability to reframe problems, it engages your imagination and thereby unlocks your Innovation Engine. Essentially, you need to be able to reorganize and rearrange the things you know and the resources you have in order to come up with brand-new ideas.

One way to practice connecting and combining ideas is to try your hand at the weekly *New Yorker* Cartoon Caption Contest. Each week the last page of the *New Yorker* has a cartoon without a caption. Readers submit captions, and the following week three are chosen to showcase in the magazine. All readers are invited to vote on their favorites. The cartoons always contain images that rarely go together, are out of place, or are out of scale. It is up to you to find a humorous way to tie the story together. The winning captions combine ideas with the images in unexpected ways. Below are a couple of examples of *New Yorker* cartoons without their captions. In one, a monster is at a dinner party, and in the other, a hobby horse is in an office. What caption would you create for each? The captions that appeared in the magazine can be found in the notes.[2]

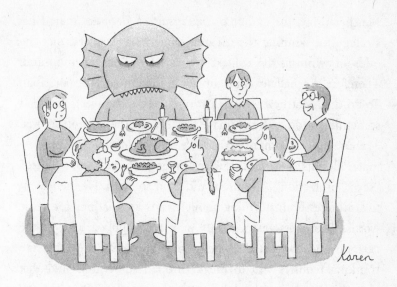

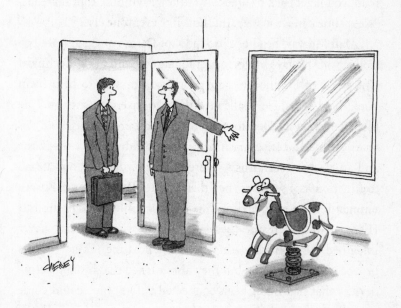

Matthew May, the author of *In Pursuit of Elegance*, shared his strategy for winning the cartoon contest. He realized that the odds of winning the contest are about one in ten thousand. Therefore, he had to come up with something truly original. To do this, Matthew wrote a list of concepts or objects that had something to do with the image. In his case, the cartoon showed a man and a woman in bed wearing protective hazardous-material suits. On his list were things such as "bed," "hotel," "sex," "protection," "germs," "suit," and so forth. He then spent five minutes brainstorming about all his associations for those words. Those new associations were then applied back to the cartoon and connected in new ways. He says, "Breakthrough thinking requires you to break through something, and that something is your normal, linear thinking pattern. By going off-road, you'll get back on track." Matthew's winning caption reads, "Next time can we just get flu shots like everyone else?"[3]

Alan Murray, head of the School of Design at the Edinburgh College of Art, gave his former graduate students at the Technical University of Eindhoven a surprising assignment to help them hone these skills. He challenged them to invent a "sextron." He told them they needed to combine two different household devices, such as a coffee machine and a blow dryer or a telephone and an electric toothbrush, to create something new, and it had to function as a sex toy. They then had to design a formal user's manual for the new device. This was certainly an edgy project! His goal was to inspire these students in ways they had never imagined. Not only did they have a wild time taking on this provocative assignment, but they also learned that by connecting devices that had never been connected before, they could come up with surprisingly innovative products that stimulate both the mind and the body, from ears to toes, in unusual ways.

On a recent trip to Japan, I asked those who were going to attend my lecture to do a similar advance assignment. They were required to pick two household objects that are totally unrelated, such as a flower vase and a shoe, and figure out some way to combine them to create something novel and valuable. The results came in several different flavors. Some were alternative, unintended uses for the objects. Others enhanced the functionality of an existing object. And then there were those rare results in which something totally brand new was created using the two familiar objects.

The unintended-use solutions from the Japanese audience included attaching an inverted baseball cap to the wall with thumbtacks to make a small basketball hoop, making an earring stand out of an egg cup and a sponge, and using lipstick and nail polish to paint pictures. In a similar vein, an art exhibit at San Francisco International Airport that I saw when I returned explored the growing interest in reusing discarded items in unintended ways. The displayed items included a large bowl made out of a car tire that had been turned inside out, beautiful jewelry made from used bottle caps, and my favorite, a dress made from fabric that was composed of candy wrappers.

Many of the Japanese creations that enhanced the functionality of existing objects involved clocks. For example, one person combined an alarm clock with vocabulary flash cards. In the morning, when the alarm clock goes off, you need to get a certain number of words correct in a flash quiz in order to turn off the alarm. Another person combined a clock with a room fragrance spray such that the clock released different scents at different times of day; morning scents are energizing, and evening scents are relaxing.

The most touching response came from a man who wrote

that he and his wife had two small children and were expecting a third child when they lost the pregnancy. They were both terribly distraught. One day the man returned home from work and his three-year-old son presented him with a doll he had created out of rolled-up newspaper and some rubber bands. He told his father, "Daddy, I made you a doll to take the place of the baby. This is for you." This sweet story is a reminder that solutions can be emotional as well as physical.

On a different scale, this type of cross-pollination takes place in our communities as ideas are randomly rearranged from cross-cultural sources. The analogy "trade is to culture as sex is to biology," from a *Wall Street Journal* article on the importance of trade in enhancing innovation, captures this concept. According to the article, communities that are at the crossroads of the world, such as ancient Alexandria and Istanbul or modern Hong Kong, London, and New York, which attract people from vastly different cultures, benefit from the cross-pollination of ideas and increased creativity.[4]

This concept was explored in depth by AnnaLee Saxenian, dean of the School of Information at the University of California at Berkeley. She has done extensive work on communities that are primed for innovation and has studied the critical factors at play in determining whether a city will be a hub of creativity. Her book *Regional Advantage* looks at the factors that contribute to the high levels of innovation and entrepreneurship in Silicon Valley. Essentially, Silicon Valley innovation is robust because of the extensive cross-pollination of ideas between individuals and companies. In Silicon Valley the firms are concentrated in a

small area, which leads to more informal interactions and easier formal connections. There are also very low cultural barriers to communication between people of different backgrounds and socioeconomic levels.[5]

For example, at a school baseball game in the San Francisco Bay Area, it is likely that kids on the same team will come from all walks of life. This means that the parents sitting in the stands watching their kids play baseball will reflect that demographic diversity. The informal discussions that take place often lead to interesting opportunities that might not happen elsewhere. A company executive or venture capitalist is likely to be sitting next to an engineer starting a new company. Their casual conversations while watching their kids play ball often lead to helpful advice, introductions to potential employees, or even funding for a new venture.

This is exactly what happened when Mark Zdeblick, an engineer and entrepreneur, was eating dinner at a local café. Two little girls from a nearby table started playing with Mark's son. Mark began a conversation with the girls' grandfather and realized that he was the inventor of a technology Mark happened to be studying. The girls' father, also at the table, was a successful entrepreneur and now a venture capitalist. After several follow-up conversations with "Dad," Mark and the girls' father decided to start a new company together called Proteus Biomedical, which develops technology for personal health and wellness.

In Silicon Valley there are endless opportunities for people to meet others they don't know and to lubricate the flow of ideas. This includes public lectures, conferences, and even cafés where people work. For example, each week at the Stanford Technology Ventures Program we host an Entrepreneurial Thought Leaders

lecture. The program is open to the public and is followed by an informal mixer. This provides students, faculty, entrepreneurs, investors, and visitors with an opportunity to hear about the latest ideas and to meet one another. This is in contrast to other places in the world where there is less social mixing and fewer opportunities to interact with and learn from others outside one's own firm or field of expertise.

Universities are designed to foster the flow of ideas across disciplines. This is why so much innovation takes place within their walls. They bring together people from different disciplines and cultures from all over the world and give them a place to work together. The students who come to learn are a great source of cross-pollination, taking classes in different fields and sharing diverse ideas with one another. They are essentially the bees that go from flower to flower sharing ideas. There are ways to encourage and enhance this type of cross-pollination. The University of California at Berkeley, for example, has a program called "Bears Crossing Boundaries" (the bear is the school mascot), in which graduate students are given incentives in the form of seed funding and prizes for projects that cross disciplines.

AnnaLee Saxenian acknowledges that innovation is almost always a social endeavor, requiring interaction with others. This interaction can be in the form of observing others, gaining advice, or direct collaboration. The more diverse the inputs, the more interesting and innovative the outputs. For instance, places in the world that have a large influx of immigrants end up with fascinating food fusions. A great example is Lima, Peru, where a new cuisine has emerged from the mixing of local Latin American ingredients and traditional Spanish dishes with a strong influence from the cuisines of China, Italy, Africa, and Japan. Im-

migrants from all of these countries have settled in Lima, combining their recipes with those of the region.

Building upon existing ideas and inventions is another way to foster innovation. In fact, when you ask artists of all types where they get their inspiration, they can usually list others before them who set the stage for their work. Painters draw upon the tools, techniques, and approaches of other artists; musicians build upon the styles of other musicians they have heard; writers are influenced by literature they have read; and inventors build upon the creations of others. As Pablo Picasso is claimed to have said, "Good artists copy, great artists steal."

Steve Jobs, the cofounder and former CEO of Apple Computer, amplified this sentiment in a 1994 interview by saying that the key to creativity is to expose yourself "to the best things that humans have done and then to bring those things into what you are doing." He goes on to say that what made the original Macintosh computer great is that the people working on it were "musicians, and poets, and artists, and zoologists, and historians, who also happened to be the best computer scientists in the world."[6] Apple took inspiration from their knowledge of these diverse fields to create something that was completely novel.

Not only is the process of connecting ideas and objects valuable for creativity—it also feels terrific. Making connections leads to "aha!" moments, which are remarkably pleasant. It is theorized that a small jolt of dopamine is released in our brains whenever we connect the dots. This occurs when we hear the punch line of a joke, when we complete a puzzle, and when we discover patterns in a seemingly random information set. This makes per-

fect sense, since our brains are designed to look for patterns.

Connecting and combining ideas occurs organically whenever people of different backgrounds and cultures get together. Some people are so aware of this that they literally go out of their way to create this type of cross-pollination in their lives in order to stir up their thinking and help them generate new ideas. I once met a salesman on an airplane who told me that he buys airline tickets for around-the-world flights with as many stops as possible. His goal is not only to get to his destination, but to meet all the people he can along the way. He knows that airports and airplanes are filled with people from all walks of life, from all professions, and with an endless variety of skills and interests. He talks with everyone in his path and makes valuable connections.[7]

Although I don't make unnecessary stops during my travels, I do make a point of talking with the people I meet along the way, and I almost always learn something interesting. For example, on a recent flight back from a business trip to Hawaii, I met a man named Patrick Connolly, who is the founder of Obscura Digital in San Francisco, which maps remarkably creative video onto any space, including the outside of the Guggenheim Museum or Trump Towers, to transform them into a multimedia extravaganza. The work he was doing was directly related to the topics I was teaching in my creativity class the next week on designing spaces to enhance innovation. I eagerly asked if he would come to class to share his experience. Patrick was happy to do so. He told the class about how they went about designing their own company's space, which won the 2011 World's Coolest Office competition.[7] His participation in the class would never have happened if he and I hadn't taken the time to connect and combine our shared interests.

Very innovative companies, such a Twitter, know how important this type of cross-pollination is to creativity in their busi-

nesses, and they make an effort to hire people with unusual skills, knowing that diversity of thinking will certainly influence the development of their products. According to Elizabeth Weil, the head of organizational culture at Twitter, a random sampling of people at the company would reveal former rock stars, a Rubik's cube champion, a world-class cyclist, and a professional juggler. She said that the hiring practices at Twitter guarantee that all employees are bright and skilled at their jobs, but are also interested in other unrelated pursuits. Knowing this results in random conversations between employees in the elevator, at lunch, and in the hallways. Shared interests surface, and the web of people becomes even more intertwined. These unplanned conversations often lead to fascinating new ideas.

Elizabeth is a great example herself; she is a top ultramarathon runner, professional designer, and former venture capitalist. Although these skills aren't required in her day-to-day work at Twitter, they naturally influence the ideas she generates. Her artistic talents have deeply influenced the ways Elizabeth builds the culture at Twitter. For instance, whenever a new employee starts, she designs and prints a beautiful handmade welcome card on her 1923 antique letterpress.

Connecting ideas that do not naturally go together is also the hallmark of innovative scientific research. Scientists who are able to do this are the ones who make the real breakthroughs. Michele Barry, the Dean for Global Health at Stanford, spends a good part of her time in the developing world trying to get to the root cause of diseases in order to wipe them out. While in Bangladesh she discussed with Bangladeshi investigators why pregnant women in the region have a much higher rate of dangerously high blood

pressure. The answer was not obvious at all. However, she and her colleagues are now trying to connect this illness to the rising sea level in the country. The land in Bangladesh is sinking, causing ocean water to infiltrate the rice fields. As a result, the rice has a higher salt content. Since pregnant women are prone to salt retention, this increase in salt in their diet may lead to higher blood pressure. This is also a great example of how two important issues—global warming and public health—intersect with each other.

Another example from scientific research comes from Robert Lane and Gary Quistad, of UC–Berkeley, who were investigating Lyme disease in northern California.[8] It was a real mystery why there are pockets in the Bay Area with a lower incidence of Lyme disease. There are just as many ticks—the vector for this disease—across all the regions, but some ticks appear to be immune to the disease. By looking beyond the obvious, Lane and Quistad realized that there are many more blue-belly lizards in the areas where there is low Lyme disease. It turns out that the lizards are naturally immune to Lyme disease. So if a tick consumes the blood of a lizard, the Lyme disease in its system is destroyed. With a large number of lizards in an area, it is much more likely that a person there will be bitten by a tick that has already bitten a lizard and is now immune. This surprising and important finding was only revealed because the scientists were willing and able to connect seemingly unrelated observations and patterns.

Ideas can be drawn from anywhere and connected at any time. Mir Imran, the founder and chairman of InCube Labs, draws inspiration for his medical inventions by connecting and combining insights from a wide range of unrelated sources, including scientific literature, patients, physicians, and even his

own personal experiences. For example, in 2000 he was stricken with Guillain-Barré syndrome (GBS), in which the body's immune system attacks its own peripheral nervous system, leading to muscle weakness and paralysis. Mir was literally a quadriplegic—unable to use any of his four limbs—for many months, but eventually recovered. Eight years later his mother was diagnosed with ovarian cancer. Mir was not focused on developing cancer treatments, but he couldn't stop thinking about the connection between the two diseases. In GBS, the immune system attacks specific cells in the person's own body. Mir wondered if the body could create an immune response to its own cancer cells. Along with others, he is working on a new treatment for cancer that involves removing a few cancer cells from patients and creating custom pathogens that can be injected back into them to trigger an immune response to the cancer in the patient's body. Once he put these puzzle pieces together, it seemed obvious. In time we will see if these observations and connections lead to more effective cures for cancer.

A great way to experiment with connections on a day-to-day basis is to use metaphors and analogies. Essentially, by comparing one thing with another you uncover fascinating parallels that open up a world of new ideas. For example, Rory McDonald, who is studying how companies in a particular industry influence each other, drew upon a metaphor for inspiration. Rory, who has four young children, decided to explore the idea that companies influence each other the same way kids do when they engage in parallel play. When children play together, they don't always actively interact but passively watch what the others do and then incorporate those ideas into their own play. When kids are play-

ing with blocks, if one child builds a castle, it is more likely that another child will build one, too. If a child adds on a tower, then others will do the same. Rory is studying the same type of behavior in the business world, and he is exploring its ramifications. In order to come up with this metaphor, Rory used both his observation skills and his keen ability to connect and combine ideas.

Metaphors and analogies are extremely powerful connectors, because they lead you to very different ways of looking at problems. In a recent study, Lera Boroditsky and Paul Thibodeau demonstrated that we get quite different sets of solutions depending on which metaphors we use to describe urban crime. If urban crime is described as a virus, then the solutions are predominantly shaped around social reforms, such as changing laws. However, if crime is described as a monster in our community, then the solutions focus on dealing with the individuals involved.[9] You can use a range of different metaphors to unlock a wider array of solutions for this problem. For example, what solutions would result if crime is compared to tracking mud into a clean house, or an unwanted chemical reaction?

Connecting unexpected people, places, objects, and ideas provides a huge boost to your imagination. You can practice this skill by using provocative metaphors, interacting with those outside your normal circles, building on existing ideas, and finding inspiration in unlikely places. These approaches enhance creative thinking and are terrific tools for generating fresh ideas.

BUILD, BUILD, BUILD, JUMP!

P lease line up according to your birthdays, from January 1 to December 31. Without talking."

As soon as I give these simple instructions to a room full of people, everyone typically freezes. It's easy to read the looks on their faces. They're saying, "Wait, that's not possible."

Then, within a few seconds, someone stands up and enthusiastically puts up a few fingers, communicating that he or she was born in the corresponding month. Everyone smiles and nods, confident that they have cracked the code. They slowly mill around the room using their new sign language to share their birthdays as they quietly form a line.

When I tell them that they have one minute to go, they start signing faster and eventually snap into a line as I count down from ten to zero. We then go through the line to see how well they did, and the giggling begins as they discover how many people are way out of place.

"What happened?" I ask.

Someone in the group explains that at first they thought that the task was impossible, and then, when someone started using sign language by raising a few fingers in the air, they all followed suit.

"Might there be other, more effective solutions to this problem?" I ask.

After a few seconds, someone inevitably suggests that they could have written down their birthdays on a piece of paper. I told them not to *talk*, but I didn't say they couldn't *write*.

In fact, there are dozens of ways to accomplish this task, most of which are more effective than using one's hands to sign the dates. As suggested, they could have written their birthdays on a piece of paper. They could have taken out their driver's licenses and shown their birth dates. Someone could have jumped up on a chair and played the role of director, instructing others to move into the right places. They could have created a time line on the floor and had everyone find their spot. Or they could have sung their birthdays. I said they couldn't talk, but I didn't say they couldn't sing. And, of course, they could have used any combination of these approaches.

The results of this simple exercise are surprisingly predictable across ages and cultures, and it uncovers a very important point: most people fall into the trap of running with the first solution they find, even though it might not be the *best* solution. The first answers to any problem are not always the best answers. In fact, much better solutions are usually waiting to be unearthed. Unfortunately, most people are satisfied with the first solution they find, missing the opportunity to come up with innovative approaches that require more effort to discover.

This is captured in the concept of the "3rd third," described by Tim Hurson in *Think Better*. His message is that the first solutions you come up with when faced with a problem are obvious. The second set is more interesting, and the third set of ideas you generate gets progressively more creative.[1] I prefer thinking about waves of ideas, because waves go on and on and on. You need

to make a concerted effort to move beyond the first and second waves of ideas in order to come up with those that push the boundaries and test the limits.

How is this actually done? This is an age-old question that has been addressed in innumerable ways. Some of the approaches are very formal, such as the "Theory of Inventive Problem Solving," or TRIZ (the Russian acronym) methodology, which was originally developed in the 1950s by Genrich Altshuller, a Soviet inventor. TRIZ is described as an "algorithmic approach to finding inventive solutions by identifying and resolving contradictions." Altshuller's book *Creativity as an Exact Science* describes his forty inventive principles.[2] Building on Altshuller's scientific approach, others created an even more detailed process called the "Algorithm of Inventive Problem Solving," which includes an eighty-five-step method for solving complicated problems.[3] Essentially, TRIZ and its descendants focus on reaching an ideal solution by looking at all the parameters of a problem relative to other parameters that are in conflict. The goal is to eliminate these contradictions in order to generate truly unique and creative solutions.

According to an article in *Bloomberg Businessweek,* many companies have reportedly used TRIZ, including Boeing, Hewlett-Packard, IBM, Motorola, Raytheon, and Xerox. Here is a sample success story:

One company that successfully applied TRIZ to arrive at an innovative product is San Diego–based OnTech. In 2004, OnTech debuted a single-serving, self-heating container that can be used as packaging for soup, coffee, tea, or even baby formula. Among the brands that have licensed the technology are a line of gourmet coffees pro-

duced by celebrity chef Wolfgang Puck and Hillside soups and coffees.

OnTech's product developers faced more than 400 technical and engineering dilemmas in trying to devise a sturdy, yet portable container that could warm drinks and stews, but could also contain and withstand the chemical reaction used to generate heat. The team surveyed TRIZ's list of 39 problems and identified those that applied, and then selected fixes from the parallel list of 40 inventive principles.

For example, they chose No. 14 from the first list— "temperature"—and applied No. 30 from the second list, "use of composite materials," as well as No. 40, "flexible shells and thin films." By using TRIZ's mix-and-match lists as a springboard, the engineers quickly arrived at a suitable material for their container: a ceramic and carbon-fiber composite that's both durable and conducts heat efficiently. Presto, a new product was born.[4]

At the other end of the spectrum are those who encourage you to get in touch with your emotions in order to unleash your imagination. Alistair Fee, who teaches at Queen's University in Belfast, Ireland, runs workshops for executives in which he encourages imagination through the task of writing poetry. At first, the highly analytical participants are reluctant, since this is way outside their normal mode of operation. But that is the point! As they work at writing, they soon get comfortable tapping into their emotions for inspiration, opening up a whole new world of ideas. They start playing with words in new ways and soon develop the ability to go beyond the first right answer. This skill spills over

into their day-to-day lives, as they become increasingly proficient at looking for alternative ways to approach the challenges of leading and managing their organizations.

Along with poetry, Alistair uses music to release his students' imagination. He asks them each to select a piece of music that resonates for them. They then have to make a video that accompanies the song they chose. The music opens up a door to their emotions, which unlocks their imagination. Even the most reserved and self-reported uncreative people blossom when given this task and come up with remarkably innovative results.

As these vastly different approaches demonstrate, there is more than one way to push beyond obvious answers to get novel ideas. However, some tools have proved to be more consistently successful. My favorite is brainstorming. Done well, brainstorming enables you to get past the first set of ideas pretty quickly and on to those that are much less obvious. Brainstorming was first popularized by Alex Faickney Osborn in his book *Applied Imagination*, published in 1953 after he had been using this approach for more than a dozen years. In this book he outlines a series of rules for brainstorming sessions. The four core tenets of his approach are deferring judgment, generating lots of ideas, encouraging unusual ideas, and combining ideas.[5]

Unfortunately, most people don't extract the most out of brainstorming, because they don't understand how different brainstorming is from a normal conversation. They think it is as easy as getting a bunch of people in a room and throwing out ideas. In fact, brainstorming is quite hard, and many of the guidelines that make it work are not intuitive or natural. For example, it is really difficult to reserve judgment when someone suggests an idea that you think is stupid. And it is hard to con-

tinue generating ideas once you think you have found a viable solution. Both of these are critically important, however, when your goal is to come up with truly breakthrough ideas.

Below is a set of guidelines to consider when hosting a brainstorming session, inspired by Tom Kelley in his book *The Art of Innovation*.[6] You will find that these guidelines help your group come up with a large collection of diverse and interesting ideas, pushing beyond the obvious first solutions. Of course, there isn't one right way to brainstorm, so I encourage you to gather ideas from others who do it well and to experiment with variations on your own.

BRAINSTORMING GUIDELINES

What does the room look like in advance?

Brainstorming is much like a dance, and similar to dancing you need the proper space to encourage a fluid brainstorming process. First, there has to be room for people to move around. In addition, just like dancing, brainstorming needs to be done standing up. This point is not trivial. By standing up instead of sitting, the group is much more energetic and engaged. Standing also allows for quick changes in the flow of people and ideas.

You also need space to capture all the ideas along the way. The most common approach is to use whiteboards or flip charts. Keep in mind that the larger the space for ideas, the more ideas you will get. In fact, when you run out of space, you often run out of ideas. So think about covering all the walls in the room with newsprint, so that the entire space can be used to capture your group's ideas. Or you can use a bank of windows as a surface for sticky notes. By the time you are done, all the walls and windows should be covered with colorful pieces of paper.

Who should participate?

Choosing brainstorming participants is critically important. It is not good enough to randomly scoop up a few people and bring them in to brainstorm. You need to be very thoughtful about who is in the room. The people invited to a brainstorming session should have different points of view and expertise on the topic. Keep in mind that this is *not* the same group of people who will make the final decisions at the end of the brainstorming session. That is so important that I will restate it: those who are in the brainstorming session are not the same people who will make the decision about what will happen with the fruits of the discussion.

If you are going to design a new car, for example, you need to include people with different perspectives and knowledge about cars. These might include the engineers who will build it, the customers who will buy it, the salespeople who will sell it, the mechanics who will repair it, the valets who will park it, and so on. These folks don't get to make the final decision about the car design, but their points of view and ideas are incredibly valuable. Dennis Boyle, at the design firm IDEO, says that being invited to a brainstorming session is a huge honor. It is a sign that your particular perspective is important. Make sure that you communicate that to those who are invited to a brainstorming session.

The size of the group is also an issue. There is always a tension between having many points of view and being able to have one conversation where everyone contributes. Several years ago I heard that Facebook had a policy of "two-pizza teams." No team was bigger than could be fed with two pizzas, which allowed for optimum communication and collaboration. Once a team got larger than that, it was broken in two. This is a great guideline for brainstorming, too. With six to eight people (and a couple of

pizzas) you have a group who can bring a range of perspectives and can also easily interact.

What is the brainstorming topic?

The framing of the topic is a critical decision. If you make the question too broad—"How can we solve world hunger?"—then it's hard to know where to start. If you make the topic too narrow—"What should we have for breakfast?"—then it is too limited. Finding the right balance is important. Recall the earlier discussion in chapter 1 about framing problems. The question you ask is the frame into which the solutions will fall. So make sure that the frame is appropriate, leaving lots of room for the group's imagination to roam. A provocative or surprising question is usually the most generative. For example, instead of asking, "What should we do for Mike's birthday?" you can ask, "What is the most fanciful birthday experience we could create for Mike?" A small change in the way you ask the question dramatically changes the tone and scope of the answers.

What else should be in the room?

It is helpful to fill the room with things that will stimulate the discussion. For example, if you are brainstorming about the design for a new pen, then you should have lots of different writing instruments, as well as interesting gadgets and toys to spark your imagination. You need to have paper and markers for everyone. It is also incredibly helpful to have other simple prototyping materials, because you will want to mock up a quick example. These include tape, scissors, cardboard, rubber bands, and so forth. Many people "build to think." The act of creating a quick example with simple materials actually helps the thinking

process. And a three-dimensional prototype often communicates much more than words or a two-dimensional drawing.

How do you start a brainstorming session?

Starting a brainstorming session isn't always easy. People have to switch gears from their everyday work mode, where their focus is on execution, to a brainstorming mind-set, where there isn't a clear destination. Doing a short warm-up exercise can lubricate the transition. There are zillions of ways to do this, from writing a progressive poem together to doing Mad Libs. One of my favorites involves giving everyone a set of paper letters that spell a long word, such as "entrepreneurship," and asking them to take five minutes to create as many words as possible using those letters. Another involves starting with a seemingly silly prompt, such as "How would you design eyeglasses if we didn't have ears?" Again, this exercise stretches the imagination and prepares everyone for the real work ahead. Although it might feel a bit awkward at first, it is important to mark the transition into a brainstorming session in some way and to give the participants a chance to warm up their imagination, just as an athlete warms up before a race.

What are the rules of brainstorming?

Real rules exist for effective brainstorming—the most important of which is that *there are no bad ideas.* This means that the participants aren't allowed to criticize ideas. In fact, no matter how strange the idea, your job is to build on it. The key is to embrace all ideas that are generated and to work with them for a while. Brainstorming is a way to explore all the possibilities, whether they are inspiring or insipid. This is the "exploration" phase of a project, which needs to be distinguished from the "exploitation"

phase, where decisions are made and resources are committed. There should be a clear wall between these two phases, so that your group doesn't fall into the trap of eliminating ideas too early. This is the biggest challenge for most people—they feel a need to evaluate ideas as they are generated. This alone will kill a brainstorming session.

It is also important to encourage wild and crazy ideas. Even though they may seem strange, there may be a gem hidden inside. The key is to generate as many ideas as possible. Give yourself a goal, such as coming up with five hundred new flavors of ice cream. Once you have come up with three hundred, you know that you only have two hundred to go. You have moved beyond the first waves of ideas and are posed to generate the most interesting and surprising recipes. It is important to remember that each idea is a seed that has the potential to grow into something remarkable. If you don't generate those ideas, then like seeds that have never been planted, no amount of time and tending will yield fruitful results. And the more ideas you have, the better. Just like seeds, you need a large number in order to find the ones that have the greatest promise.

One way to break free from expected ideas is to encourage silly or stupid ideas. In my last book, *What I Wish I Knew When I Was 20*, I describe an exercise in which I ask students to come up with the worst ideas they can during a brainstorming session. This unleashes ideas that would never have surfaced if they only focused on their best ideas. When people are asked to generate bad ideas, they defer judgment and push beyond obvious solutions. In fact, the craziest ideas very often turn out to be the most interesting ones when looked at through the frame of possibility.

What is the brainstorming process?

Once you have the right space, people, and question, and have reminded everyone of the rules, your goal is to make the process as fluid as possible. Only one conversation should be happening at a time, so that everyone is in sync. Along the way, you are going to want to challenge participants to look at the problem from different points of view. One approach is to remove the most obvious solutions from the pool of possibilities, so that you have to come up with something else. This forces you to tackle the challenge without the expected tool in your toolbox. For example, if you are brainstorming about ways to make it easier to park your car in a busy city, the expected answer is to add more parking spaces. If you eliminate that possibility, then other, less obvious answers will emerge.

During a brainstorming session, you should also throw out surprising and provocative prompts along the way that will help the group push past their assumptions. For example, if you are coming up with ideas for a new playground, you could ask how someone might design a playground on the moon or underwater. You could ask how you might design it one hundred years in the future or in the past. You could ask how a child would design it or someone with a disability. You could ask how you would design it with one dollar or with a million dollars. Or, you can solicit ideas for the most dangerous playground in the world. In fact, studies have shown that the farther away you get from your current place and time, both physically and mentally, the more imaginative your ideas. These prompts provide a convenient way to do this.

In addition, it is important to build on other people's ideas. In a perfect brainstorm, there is a rhythm to the discussion, and

it feels like a dance. Someone comes up with an idea, and several people build on it for a short time. Then you jump to a new approach. The dance could be called "Build, Build, Build, Jump!" To make this work smoothly, all the ideas should be written as short statements, such as "Build a house on the moon" or "Give everyone a key to the building," rather than long descriptions that look like business plans. The short statements are like newspaper headlines for each of the ideas.

How are ideas captured?

Make sure that everyone has a pen and paper or sticky notes. This might sound remedial, but it isn't. If only one person is at the board writing down ideas, then they control which ideas are captured. When everyone writes, you avoid the "tyranny of the pen," where the person with the pen controls the flow of ideas and what is captured. In addition, if everyone has a pen and paper, they can write or draw their ideas in real time, without having to wait for a hole in the conversation. When they do speak up, they will have already captured their idea, so it will be faster to add it to the board.

Using sticky notes enables each person to write down ideas as they arise and then put them on the board when the time is right. They also force participants to write short "headlines" to summarize each idea rather than spending too much time writing lots of details. Sticky notes also allow you to reorganize and cluster similar ideas together as patterns emerge. All this adds to the creative spirit of the brainstorming session.

Another valuable way to capture all your ideas is using mind mapping. This is essentially a nonlinear way to collect ideas. Starting with a central topic on the board, you draw lines to words or drawings with related information, and then add details

to those on smaller branches. For example, if you were using a mind map to brainstorm about the plot for a new mystery novel, you might put the title in the middle of a mind map. You would then draw lines to text or images around the center, which might include characters, settings, story line, and historical context. You can add ideas to each of these on smaller branches around them. A quick online image search for mind maps reveals an endless array that you can use for inspiration. Here is a sample mind map created by Paul Foreman with main branches that deal with who, what, when, where, and why to mind-map:

How much time does a brainstorming session take?

It is generally impossible to keep the energy needed for productive brainstorming going for more than about an hour. This means that there should be a clear limit to the amount of time you brainstorm. A flash brainstorming session of ten to fifteen minutes will work if all the participants know each other well

and can quickly dive into idea generation. A longer session of forty-five to sixty minutes yields the best results. A key is to make the session long enough to get beyond the early waves of ideas. However, these longer sessions should be broken up into smaller segments by injecting various prompts along the way in order to keep the discussion fresh and everyone engaged.

It is best to end a brainstorming session on a high note, leaving everyone wanting more. In fact, few things feel better than a robust brainstorming session. Everyone feels invigorated and validated, as others build on their ideas. At the end of the session, the room should be saturated with ideas. There should be words and drawings covering the walls and prototypes on the tables. It should look and feel as though the subject has been fully explored, providing a rich collection of material that can be mined.

What do you do when you are done?

Sometimes the end of a brainstorming session is the most challenging part of the process. As discussed earlier, those who are part of the brainstorming session represent a wide range of perspectives, but are not the ones who will decide which ideas to implement. Even so, the participants are usually eager to pick their favorite ideas, and it is helpful to know their preferences. To address this, you can give all the participants a chance to vote for their top choices in several different categories. For example, ask each person to put a red star next to the ideas that will have the biggest impact, a blue star next to those that can be implemented quickly, and a green star next to the ideas that are most cost-effective. This process gives the decision makers useful input on what to do next, and it provides everyone involved with a chance to express an opinion.

The final step is to capture all that happened. Take photos of all of the ideas, make notes about the best ones, and save all the materials that can be saved. They are the valuable products of the brainstorming session. The person or team who is in charge of making the decisions about the project can mine this massive collection of diverse ideas and decide which ones to pursue. These materials can be revisited at any time in the future. As time goes by, some of the ideas that seem impractical might look promising.

Here is an example of how this all works. Just recently, we launched a new national center at Stanford called the Epicenter, for the National Center for Engineering Pathways to Innovation.[7] The center is charged with transforming undergraduate engineering education across the United States. To kick off our planning, we had a brainstorming session. I spent several hours in advance planning for the session, coming up with an appropriate warm-up exercise, crafting a series of questions to frame the brainstorming, gathering materials to stimulate the discussion, setting up the room, and identifying the right people to include in the session.

I picked a series of topics that would allow us to come at the challenge from different angles. For example, we started with the broad question "What can the Epicenter do that will have the biggest impact?" I threw out different prompts along the way, including "What if we were doing this for five-year-olds instead of twenty-five-year-olds?" "What if we had $100 million instead of $10 million?" and "What if we had no money at all?" We then switched to related topics every ten minutes. For example, we brainstormed about how to reward people for participating, how

we will know if we are successful, how to design our physical space to reflect what we are doing, and how we should share the resources on our website.

Each short session reinforced the previous one, providing a new way of seeing the challenge and sparking new ideas. Many of the ideas were extreme, such as owning our own private jet. But many others were incredibly interesting, such as lining the walls of our new space with computer monitors with live connections to universities around the country, having movie clips on our website showing how innovators are portrayed in the media, having a gift shop so that we can offer visitors tangible tools to take home, and launching an "Entrepreneur Ship" that stops at different ports where passengers are given projects that reflect the local challenges at each location. When we were done, the entire wall of windows in our office was covered with hundreds of colorful sticky notes.

Done well, brainstorming allows you to tap into your imagination to challenge assumptions and to push beyond obvious answers to generate truly interesting and unique ideas. It is a fabulous way to find nonobvious solutions to problems big and small, and it is a critical technique for all innovators. The more you practice, the more fluid your brainstorming becomes, and the more diverse the ideas you and your team generate. As such, brainstorming is a key to enhancing and expressing your imagination.

ARE YOU PAYING ATTENTION?

Richard Wiseman, of the University of Hertfordshire in the United Kingdom, handed test subjects in his laboratory a newspaper and asked each of them to count all the photos inside. Wiseman picked subjects for this experiment by recruiting individuals who identified themselves as being either extremely lucky or terribly unlucky. He wanted to see whether those people whose lives are filled with good fortune actually see the world differently than do those who are star-crossed. What do you think happened?

In this experiment, the unlucky people took several minutes to count all the photos in the newspaper, and most came back with an incorrect answer. The lucky people, on the other hand, took only a few seconds to find an answer, and they were *all* correct. Why was this?

Wiseman designed special newspapers for this experiment. Inside the front cover of each newspaper there was a two-inch-high message that read, "STOP COUNTING. THERE ARE 43 PHOTOGRAPHS IN THIS NEWSPAPER." Both groups were looking for photos, as requested, but the lucky people also read this message and responded accordingly. In contrast, the unlucky people

were focused *only* on counting the photos—since that was their specific assignment—and they didn't see the message with the answer they needed.

To test this result further, Wiseman gave the unlucky participants another shot at success. Halfway through the newspaper he placed a second large notice that said, "STOP COUNTING. TELL THE EXPERIMENTER YOU HAVE SEEN THIS AND WIN £250." Not a single person claimed the money.[1]

This elegant experiment shows that people see the world very differently. In addition, it demonstrates beautifully that by ignoring information in your environment, you miss important clues that are the keys to solving problems. In fact, the world is filled with endless two-inch-high messages, and it is up to each of us to discover them.

My colleagues Michael Barry and Anne Fletcher teach a class at the d.school on need-finding, which deals specifically with focused observation in order to identify opportunities for innovation. The entire class is designed to prepare students to be keen observers. They start out with a wonderful story by the late American novelist David Foster Wallace:[2]

Two young fish swim past an older fish. As they pass the older fish, he says, "Morning, boys. How's the water?" The two young fish continue on for a while until one eventually asks the other, "What the heck is water?"

The message in this fable is that we so often don't notice the things that are most important in our lives. We are literally blind to the "water." Michael and Anne spend ten weeks teaching their students how to see the "water" in their lives as they identify surprising and valuable opportunities.

I recently participated with Michael Barry in a weeklong workshop on design thinking for graduate students in which the participants were challenged to redesign the "dating experience." With Michael's coaching, they identified a wide range of interesting problems they had never noticed before. For example, they uncovered the challenges faced by busy and bored couples and by those who want to end a relationship that isn't working. Their solutions reflected their newly found insights. One team designed a new business with "Dating Agents," who package interesting excursions for couples who are tired of doing the same things over and over. They are essentially travel agents for daters. Another team designed a "Relaunch Kit," complete with a "Breakup Buddy," to help end sour relationships. These students learned how to see the world around them with focused attention, to find new opportunities, and to come up with unique solutions to the problems they identified.

Acute observation is a key skill for gaining valuable knowledge about the world around you. This knowledge is the fuel for your imagination. Steve Blank, a serial entrepreneur, provides a great example. He has been on the founding team of eight different companies, and many people have praised Steve for his creativity and fearlessness. He chuckles and says, "I'm not brave. I'm just incredibly observant." Steve has discovered that the more you observe, the more data you collect, the more patterns you see, and the more boldly you can act. As Steve would say, "This is a big idea!"[3]

In 1988, for example, Steve was brought in to run marketing at a company called SuperMac, which made graphics boards for computers. At the time the business had just emerged from bankruptcy. The company had only a 10 percent market share, which was way below the other two leading players in the field. As Steve

put it, "They were twentieth in a field of three." Soon after he arrived, Steve noticed an enormous pile of fifteen thousand product registration cards that had been sent in by customers. They were stacked up recklessly in the corner of the break room. He asked his colleagues about this massive stack of cards and learned that they were just piling up, year after year. Everyone was much too busy executing their plans to take a look at these seemingly meaningless pieces of paper. Steve started digging through the pile himself and quickly realized that they contained a gold mine of information.

Steve randomly pulled out three hundred of the most recently received cards and started calling these customers himself. He asked them what business they were in, how they used the graphics board, what its most important attributes were, how it could be improved, and how much they would be willing to pay for it. He learned a tremendous amount from each call, and the collective information allowed Steve to make decisive choices about product positioning and pricing, with great confidence that they would work. Within a short time, Steve overhauled the advertising and promotion of the product line and increased the prices. As a result, the company's market share increased from 10 to 70 percent. This would never have happened if Steve had not paid attention to the little pieces of paper that others ignored. To those who didn't understand what he was doing, Steve looked fearless.

Another compelling example comes from David Friedberg, the founder of the Climate Corporation.[4] While working at Google, David passed a small bike-rental shack each day as he drove to work. Over time he noticed a pattern: whenever it rained, the shack was closed for business. This observation led to the insight that millions of businesses are influenced by the weather, including farms, movie theaters, and ski resorts. He

decided to leave Google to start a company that sells insurance to protect businesses from weather-related losses. David would never have come up with this idea, and launched this successful venture, had he not paid careful attention to the world outside his car while driving to work.

As children, we are naturally curious and intensely observant as we try to figure out how the world works. As we get older, many of us shut down our natural curiosity and observation skills. We think we understand the world and look for the patterns that we already recognize. As Jeff Hawkins, the founder of Palm Computing, Handspring, and Numenta, describes in his book *On Intelligence,* our brains are natural pattern-recognition machines that are constantly filling in the gaps in our observations with what we think should be there.[5] We become skilled at predicting what we will experience, and then we experience the things we predict.

It takes considerable effort to focus our attention beyond what we anticipate, especially when we are dealing with familiar experiences. For example, we literally tune out when we're performing repetitive activities, such as driving or walking on routine paths. We also focus predominantly on things that are at our eye level rather than looking around more broadly. In addition, we pay attention to objects that we expect to find and ignore those things that don't fit.

Recently, while waiting in line at Bianchini's, our local grocery store, I happened to glance up toward the ceiling. I've been in that store thousands of times and was astonished to realize that there is an entire farm scene, with huge wooden cows, chickens, and real bales of hay, displayed on a high ledge that goes around the entire

store. I mentioned this to the man working at the checkout counter and asked if this display was new. He laughed and said that all the cows and chickens have been there since the store opened years ago. I had fallen into all three of those traps!

Unfortunately, I hadn't gone through the same training as my son, Josh. My father played a game with him and his cousins, Adam and Noah, when they were growing up, to teach them to pay careful attention to their environment. Whenever they were in a new place, my father would playfully ask the boys to shut their eyes, and he would quiz them about the details of the room. He'd ask questions such as how many windows there were, how many doors, and how many lights were on the ceiling. They loved this game and learned to be incredibly observant in order to be prepared for these pop quizzes from their grandfather.

Magicians and illusionists know that we *believe* we are fully aware of our environment and are paying careful attention to everything that is going on. They understand that almost anything can distract us, including a good story, a joke, or pointing to someone across the room, which draws our gaze away from what is really happening in front of us. Most magic tricks rely upon magicians' ability to distract us while they perform their sleight of hand. For example, a magician puts six cards faceup on a table and asks you to select one from the lineup, but *not* to pick it up. She asks you to memorize that card, keeping this information to yourself. She then tells you that she will read your mind to determine the one card that you selected. She picks up all six cards, looks at them carefully, and puts five cards back down on the table, telling you that the card you selected will be missing from the lineup. She's right. Your card is gone! How did she know?

If you were really paying careful attention, you would see that

all five of the cards she placed on the table had changed. The magician didn't need to know which card was yours. She just had to count on the fact that while you were focusing on one card, you wouldn't notice the difference between cards that look similar, such as a king of hearts and a king of diamonds; or between a queen of spades and a queen of clubs. Magicians take full advantage of our lack of focus and our ability to be distracted as they make objects appear to disappear, as they cut people in half, and when they pull rabbits out of hats.

On the flip side, humorists draw our attention to the things in our environment that we usually ignore. By focusing our attention on seemingly mundane acts, such as parking a car, brushing our teeth, or waiting in line, we become aware of actions and objects that we don't normally notice, and they become funny under such focused scrutiny. The famous comedian Jerry Seinfeld is known for talking about *nothing*. The subjects of his humor are funny, because he focuses on experiences that don't normally grab our attention. They are the little things that we don't usually notice in our daily life. Here is a short example:

> I hate the waiting room because it's called the waiting room, so there's no chance of not waiting. It's built, designed, and intended for waiting. Why would they take you right away when they've got this room all set up? And you sit there with your little magazine. You pretend you're reading it but you're really looking at the other people. "I wonder what he's got." Then they finally call you, and you think you're going to see the doctor, but you're not. You're going into the next smaller waiting room. Now you don't even have your magazine, and you've got no pants on.[6]

Observation is an active process that takes significant effort. With practice, however, you can effectively turn up your powers of observation. A compelling example occurs every December when the Audubon Society hosts its annual Christmas Bird Count. This event, which has taken place for over a hundred years, is designed to take a detailed census of birds over a twenty-four-hour period. Each observation site, or count circle, is fifteen miles in diameter, and together they cover the Americas, from the Arctic to Antarctica. This project was started in 1900 in response to the annual Christmas "Side Hunt," which, sadly, rewarded hunters who brought in the biggest pile of dead birds. Conservation groups, including the newly forming Audubon Societies, worried about declining bird populations and decided to counter the hunt with an annual census of birds across the country.

That first year there were 27 participants in 25 locations who counted 90 different species. In 2010, 110 years later, there were over 61,000 observers in more than 2,200 locations, and nearly 2,250 different bird species were identified, including over 640 in the United States. Some people travel to remote locations to observe and identify birds, braving wild weather and winter storms, while others watch the bird feeders right outside their kitchen windows. The key is that they set aside the day to pay careful attention and then submit their findings to those who compile all the results.

Lynn Tennefoss, a national leader at the Audubon Society, told me that people who participate in the annual bird count learn to be astute observers. Once they practice the art of focused observation and become skilled at spotting the birds in their region, they admit that they become much more attuned to the world around them. They start noticing the birds they had never seen before and become much more observant in general.

Scientists and artists of all types are the world's "noticers." They are trained to pay attention and to communicate what they see and experience to the rest of us. For example, Charles Darwin is credited with the idea of evolution by natural selection. He polished his ability to pay attention during his five-year journey on the HMS *Beagle,* from 1831 to 1836, and upon his return to England as he studied all the specimens and drawings he brought back from the Galápagos Islands. Tiny differences in the beaks of finches and the shapes of tortoise shells served as evidence for his provocative theories. This is a poignant reminder of the power of observation.

Inspired by Darwin, Bob Siegel decided to teach students to hone their powers of observation in a class he taught for Stanford sophomores called "The Stanford Safari: Field Observations in Our Own Backyard." Bob is an award-winning professor in the Department of Microbiology and Immunology who also teaches in the Center for African Studies. He is used to leading expeditions to far-off lands, such as Papua New Guinea or Tanzania. The Stanford Safari was crafted to teach students to see things that most people in the same environment pass every day without noticing.

Each day, students were required to make a series of observations about the campus in a field notebook. They met with a vast range of people, including four former Stanford presidents, the deans of the schools of medicine, law, and business, and the heads of the offices of admission and religious life. They tried to meet with all those who have "university" in their title, including the university ombudsman, archivist, archeologist, organist, counsel, architect, horticulturalist, librarian, and even the university pest controller. Each provided a unique point of view about the university.

They visited famous and infamous places on campus and kept track of all their observations in photos and on a class website. In addition, each day of the Stanford Safari the students ate at a different campus eatery. This might seem terribly mundane. But this simple act reminded the students that they so often fall into routines, such as eating at the same café day after day, when over thirty different options are available on campus. They learned a tremendous amount about Stanford, but the most salient thing they learned from this intense experience is that by opening your eyes, paying attention, and asking lots of questions, there are remarkable things to see around every corner.

True observation is a very active experience. It involves focusing all your senses and actively engaging with your environment. It requires capturing your findings in words, drawings, photos, and recordings. In fact, it is rare to see Bob Siegel without a large camera or two hanging from his neck. He is always taking photos to help him observe the world in great detail and with deep appreciation. By capturing his experiences, he actually sees much more than those of us who think we are paying attention when we really aren't.[7]

I also give my students a chance to practice their observation skills and to enhance their powers of paying attention. We go to a spot that they have all visited many times before, and I challenge them to see it through fresh eyes. We meet at a local shopping center, where teams of students spend at least two hours visiting a handful of stores and making careful observations. Here is a sample of the questions they answer in each store they visit:

OBSERVATION LAB

Before Entering

- What is in the window of the store?

- Does this store draw you in? If so, how?

- Is the door to the store open or closed?

- How big is the lettering of the store name?

Environment

- What is the color scheme of the store?

- What type of floor does the store have?

- How high is the ceiling? How does this feel?

- How brightly lit is the store? How does this affect you?

- How loud is the environment?

- Is there music playing? What type?

- Is the store crowded with merchandise, or is it sparse?

- Does the store appear very organized, or is it cluttered?

- Does the store have a distinctive smell?

- Where is the cash register located?

- How visible is the store security?

Personnel

- How long does it take a salesperson to initiate contact?

- Does the salesperson have a script to follow?

- What is the ratio of salespeople to customers?

- What age and gender are the employees?

- Do the salespeople appear to have a uniform?

Products

- Is there a central display table with featured products?

- Which products are at eye level?

- Which items in the store are least accessible?

- Where are the most and least expensive products?

- Are the prices of the products easy to find?

- Are there impulse items near the cash register?

Customers

- What is the average age of the customers?

- How long do customers stay in the store on average?

- Do most customers appear to be on a mission?

- What percentage of customers purchase products?

- Is this store equally accessible to disabled customers?

It isn't good enough to make acute observations. You need to find an effective way to capture them to make them stick. Artists do this by preserving their observations in an endless variety of ways. They articulate what they experience in paintings, photographs, dance movements, and words. The act of capturing observations logs them in your mind. This is one of the reasons that art and music classes are so important. Learning about art is much more than learning how to paint a picture, make a photograph, or create a sculpture; it is about how to observe the world with great attention to detail, to internalize those observations, and then to give expression to them in the chosen medium.

Artists of all types collect and archive observations and ideas. Twyla Tharp, the famous choreographer and dancer, writes about this in her book *The Creative Habit.* She writes down all of her observations and ideas on scraps of paper and throws them into a box for each of her projects. She can then mine the material in that box when she is looking for inspiration. She says:

> I start every dance with a box. I write the project name on the box, and as the piece progresses I fill it up with every item that went into the making of the dance. This means notebooks, news clippings, CDs, videotapes of me working alone in my studio, videos of the dancers rehearsing, books and photographs and pieces of art that may have inspired me. The box documents active research on every project. . . . There are separate boxes for everything I've ever done. If you want a glimpse into how I think and work, you could do worse than to start with my boxes. The box makes me feel organized, that I have my act together even when I don't know where I'm going yet. It

also represents a commitment. The simple act of writing a project name on the box means I've started work.[8]

Focused observation and commitment to really seeing what is happening is an important key to successful product design at firms such as IDEO, which is known for its innovative solutions to complex challenges. According to Dennis Boyle, IDEO was hired by the American Red Cross to redesign the experience of giving blood, with the goal of encouraging individuals to donate blood more frequently. The obvious solutions involved rethinking the flow of people through the blood-donation process and redesigning the tables, chairs, and the equipment used at each donation site. IDEO addressed these issues by creating custom equipment that all fit together, making donors feel more comfortable by giving them a consistent experience.

The IDEO design team didn't stop there. They continued to observe all aspects of the user experience and, by paying careful attention to the details and talking with those who were donating blood, they gained unexpected insights about the donors' motivation for giving blood. It became clear that each person who donated blood had a moving story to tell about the reason for doing so. These personal accounts, which would have been invisible to those who did not talk with the donors, were a critical part of their blood-donation experience.

The designers captured the donors' emotions by taking a photo of them individually and asking them to write a short story titled "Why I Give." The stories were then displayed on boards at the donation sites, encouraging others to donate, too. Now, when you go to the Red Cross website, the home page has a large photo of a donor with a short story about his or her reason for giving blood, and links to nearly a hundred additional stories. This in-

sight and opportunity would never have been uncovered without careful attention to those things that are typically outside our field of view.

Great innovators in all fields use this type of focused attention to identify opportunities and solve problems. Mir Imran, mentioned earlier, uses acute observation to identify opportunities for important medical breakthroughs. Mir admits that without laser focus and detailed observation, he would never have been able to conceptualize and develop the dozens of medical inventions he has created. These inventions treat a mind-boggling range of ailments from headaches to heart disease and from asthma to Alzheimer's disease, using a dizzying range of disciplines, including chemistry, biology, physiology, electronics, and product design.[9]

Mir reads massive numbers of research journals, mining them for insights. He admits that he "doesn't believe any of it." In fact, he questions everything he reads and is always looking for patterns as well as inconsistencies. He goes back and forth between the tiny details and the big picture, figuring out where the tiny puzzle pieces fit together and where there are holes. This is critically important. Meaningful observations require changing the scale of observation from close up to far away and back again, so that patterns become evident at any or all levels of resolution.

As a result of his intense exploration of the field, Mir Imran created a brand-new way to treat atrial fibrillation (AF), a condition in which the heart beats irregularly. AF often results in blood pooling in the chambers of the heart, which leads to the formation of small clots. If these clots are dislodged and flow to the brain, they can get stuck in the tiny vessels and cause a stroke. This is very dangerous. Most patients with AF are treated with drugs to stop the irregular heart rhythms. However, beginning in the 1990s cardiologists began using a new treatment to end AF,

called ablation. They literally go into the heart and make multiple incisions or burns in the atrium, which blocks the electrical currents in the heart that cause the fibrillation. This procedure does a great job of stopping AF and has become the "standard of care" for treating this ailment. According to Mir, over a hundred thousand of these procedures are performed each year in the United States, and many companies have been formed to make different types of tools to ablate the heart tissue.

Mir decided to look at the data with a different set of lenses. First, he couldn't imagine that damaging the heart by destroying a part of it is actually a good thing for patients. Second, he noted that AF happens periodically and wondered if there was a way to treat this condition as needed, without permanently damaging the heart. This motivated Mir to consider other alternatives for stopping the fibrillation. He found that if he released a minuscule amount of an antiarrhythmic drug around the heart, it instantly stopped the arrhythmia.

Mir invented a small implantable pacemaker with a drug pump. If the heart experiences atrial fibrillation, the pacemaker releases a tiny amount of the drug near the atrium. The AF instantly stops. This treatment, which will be tested in humans, should remove the need for patients to take drugs, eliminate the irreversible damage to the heart caused by ablation, and treat the heart only when patients experience fibrillation, reducing the risk of stroke and heart failure. Corhythm, Inc., a spin-off from InCube Labs, is currently commercializing this new treatment for AF. This would never have been accomplished if Mir had not paid careful attention to a wide range of factors related to treating AF.

Focused observation is a powerful way to acquire valuable knowledge about the world. That knowledge is the starting point

for all your creative endeavors because it provides rich fuel for your imagination. You can practice polishing your powers of observation by actively looking at the world with fresh eyes, by seeing the "water" in your environment, and by capturing your observations. Observation is a critical skill for all innovators. So, I hope you were paying attention.

FIVE

THE TABLE
KINGDOM

Liz Gerber was running a workshop at the d.school on creative problem solving for a group of business executives, when one of the participants lamented that their team's workspace was confining, making it difficult to comfortably collaborate. The group asked if they could move to a bigger space. Liz handed them an electric screwdriver and told them to take down the plywood walls, which were easily dismantled. Their jaws dropped open when they realized that was an option, and they quickly removed the wall to create a much bigger workspace and dove into their project, filling the expanded space with artifacts and ideas.

The spaces in which we live and work are the stages on which we play out our lives. As such, they have a huge impact on our thoughts and behavior. From the moment we are born we respond to the space around us. It has been shown that children who grow up in stimulating environments have brains with a more highly developed neocortex, the outer layer of the brain. And there is evidence that such people are more capable of solving complex cognitive problems later in life. That's why new parents often try to create a rich environment for their babies and young children. They surround them with bright images and toys

that activate their nervous system and spark their imagination. Kindergartens strive for an equally stimulating environment. Rooms are filled with manipulatives such as blocks and Legos®, there is an abundance of brightly colored books and games, and the furniture is designed so that kids can work independently, in groups, or as an entire class.

Unfortunately, as children get older, classrooms get less and less inspiring. Eventually, in high school and college, desks and chairs are usually lined up in rows and bolted to the floor, facing the front of the room, where the teacher lectures while students passively take notes. They have sadly graduated from an environment that is designed to stimulate their imagination to one that inadvertently crushes it. And when they head off to work, many of these graduates find themselves in offices with rows upon rows of sterile cubicles. Furthermore, in many places in the world, these offices are dimly lit and filled with cigarette smoke.

What type of messages do these environments communicate? When you enter any space, you are immersed in a narrative and become an actor in that story. You know your role and what is expected of you. For example, how do you feel and act when you walk into a lecture hall, a hotel room, an airport terminal, a doctor's office, a concert hall, or a playground? Each space compels you to respond differently. Most likely, you expect to be a passive observer in a lecture hall; you assume that others will clean up after you at a hotel; you will probably feel out of control at an airport; you know you will have to wait to see your doctor; you count on being entertained at a concert; and you expect to entertain yourself at a playground. Therefore, if you are creating an office, classroom, or family room where you want people to be inventive, you need to keep in mind that the design of the space really matters. Space is one of the key factors in all habitats, along

with the rules, rewards, and constraints, which will be discussed in later chapters.

While writing this I am sitting outside at Coupa Café in Palo Alto, California, on a warm summer evening, surrounded by lots of people who are casually sipping coffee and chatting with friends. Some are in small groups, and others are sitting by themselves. This open space invites you to linger, to watch passersby, and to start a conversation with someone sitting at the next table. In fact, a young man just introduced himself to me and handed me his business card. Blazoned on the front are the words "Ryan Schwartz, ENTREPRENEUR." New to town, he wanted to meet new people and picked this spot because he understood that here it would be perfectly fine for him to introduce himself to others.

Right down the street is a restaurant with a very different ambience. I'm sure you can picture it: subdued, with small tables and quiet music, conducive to private conversations that will not be interrupted. Here it's much less likely that you would start up a conversation with someone sitting at another table. I consciously decided to sit outside at the café, because, like others, I wanted to be surrounded by the low buzz of the crowd and the potential for brief interruptions and inspiration.

This might all seem obvious. However, most of us don't take such factors into account when we design the habitats in which we live and work. When you look around your space, think of all the variables that influence how you feel and act. Consider the height of the ceiling, observe the brightness of the lights, listen to the volume of the music, and pay attention to the smells of the room. Each of these factors affects everything you do, how you feel, the way you work, how you learn, and how you play. Real

estate agents know this well. That is why they turn on all the lights and often bake cookies at an open house. They know that the bright rooms and the smell of the freshly baked cookies will produce a warm feeling about the house, making you more likely to want to buy it. Even though you know what they are doing, it still works.

Architects are extremely aware of all of these variables and consider them each time they design a new building. Jeanne Gang, a renowned architect from Chicago who recently won a MacArthur "genius" award, is known for designing dramatic buildings, such as the Aqua Tower in downtown Chicago, which looks as though it is being blown by the unrelenting wind of that city, and the Starlight Theater in Rockford, Illinois, the roof of which opens like a flower. Her firm is remarkably inventive, and the team needs to work in a space that encourages the creation of innovative solutions to all the architectural challenges that come their way.

Jeanne told me that they consciously designed a work space that is slightly "out of control," filled with myriad objects that stimulate the imagination. There are found objects from all over the world, such as rocks and minerals, building materials, musical instruments, fabrics, and crafts that offer inspiration for the projects on which they are working. The building is intentionally outside the city center, in an old bank building that they gutted and made their own. It is a relaxed environment on the inside and the outside.

In addition to their open studio space, they have three unique meeting rooms, each consciously designed for different types of creative work. The rooms are different sizes and shapes, and the furniture reflects the goal for the space. The orange room is designed for all-day workshops; it has soft chairs and one big round

table for group work. It opens onto both the model shop and the kitchen for easy access to prototyping materials as well as food. Another room, predominantly white, is designed for formal presentations. Outfitted with a rectangular wooden table, this room opens out to the garden. The silver room is designed for talking, not prototyping. It is an intimate space with a white round table and views of the activity in the street. Overall, Jeanne has built an environment where people aren't worried about making a mess, where everything is flexible, and where the space—both inside and outside—reflects the goals for those inside.

My favorite example of Jeanne's work is a large flowing curtain constructed of marble tiles and weighing 1,600 pounds. In this stunning piece she combines materials—stone and fabric— and unlocks previously unknown properties of marble by slicing it surprisingly thin. The interlocking pieces create a translucent marble curtain that is suspended from the ceiling. It is unlikely that ideas such as this one would have come out of a space that didn't inspire the creative connection and combination of unlikely ideas and materials.

A completely different example comes from Square, Inc., a San Francisco firm dedicated to making mobile financial transactions simple. They make a small white square device that plugs into a smartphone and allows anyone to collect credit-card payments. The firm's directors are extremely aware that the products it releases are a direct reflection of the space in which employees are working. They want their products to be simple and "breathtakingly elegant" and have explicitly designed their office space with the same aesthetic. There is one enormous room with rows of long white tables where everyone works in the open. In addition, there are elegantly designed conference rooms that are enclosed in glass for private conversations. Everything is clean,

neat, and open, and all employees are required to keep their own desks clear of clutter. The message is loud and clear: this is a place where simplicity is valued and expected. In addition, the open environment is a reflection of the company's extreme transparency. According to Michael White, who works at Square, they take detailed notes at every single meeting, which are posted on the company's internal website for all to read.

I am fortunate to work in several interesting spaces at Stanford University that are designed for very different types of activities. One is the Stanford d.school, where I teach my course on creativity. It is fascinating to watch people as they walk into the d.school for the first time. Without a word from anyone, they know this is a place designed for creative endeavors. There aren't any cubicles or offices. There aren't lecture halls or chalkboards. Instead, the entire space is more like an improvisational theater, where the set changes day to day and often hour to hour to meet the needs of those using it.

One of the reasons I appreciate teaching in the d.school is that we can design the classroom differently for each session, depending upon what we are doing that day. Sometimes the students sit in small groups around tables that easily roll into place; other times the chairs face the front for presentations. Sometimes the students are arranged in pairs; and other times the room is divided into halves or quarters, with different activities happening in each section. All of the furniture, including tables, chairs, whiteboards, and foam cubes (which can be used for sitting or for carving up the space), is designed to move easily and to essentially disappear when not needed, so that the teaching space can be transformed almost instantly, sometimes several times during one class session. The room is always stocked with an endless array of prototyping materials, so anyone can quickly mock up

an idea. In addition, there is a video studio where students can make movies that tell the story of their projects. And the space is filled with wonderful artifacts from past projects as inspiration.

This is not accidental. Tremendous thought went into designing a space that is optimized for creative problem solving. A "space team" at the d.school is led by Scott Doorley and Scott Witthoft, who are always evaluating the d.school environment and experimenting with new ideas. For example, recently one of the lead instructors at the d.school was sitting in the reception area. I greeted her and asked what she was doing. She told me that the space team was redesigning the experience people have when they enter the d.school. They wanted to make that experience as positive and reflective of the spirit of the school as possible. When I came by the next day, the entire reception area was changed—they were trying out a brand-new arrangement. The d.school team knows that space plays a huge role in people's experience, and they go to great lengths to find a way to build spaces that create the response they want to evoke. Scott Doorley and Scott Witthoft have captured what they've learned from their extensive experimenting with space in a new book called *Make Space: How to Set the Stage for Creative Collaboration*.[1]

Experimentation with space happens all the time at the design firm IDEO. Few things are bolted down, and people are always rearranging the space. When I met with Dennis Boyle, a partner in the firm, we sat inside an old van that is parked in the middle of the office. This started as a joke years ago. A colleague left for vacation and came back to find his office moved into the back of a transformed van, which was set right in the middle of the building. He used it for several months, after which it was turned

into a meeting room that anyone can use. This type of playful experimentation with space happens all the time. When employees leave for a few weeks, they can be pretty sure that the space to which they return will be redesigned. Dennis listed dozens of examples, including turning one office into a boat while someone was on a cruise, turning another into the Eiffel Tower when a fellow designer was vacationing in France, and decking another out with a patriotic celebration in red, white, and blue when a colleague finally earned a green card.

Redecorating offices is far from frivolous. It builds on IDEO's culture of experimenting with space, and this type of experimentation has led to dramatic changes in the ways teams work together. In the early days, thirty years ago, everyone at IDEO had an office. They then moved to an open seating plan where everyone worked in cubicles. Each designer decorated the cubicle to reflect his or her interests. Now they all sit together in project teams, and there are no offices at all. These studio spaces initially evolved around long-term or secret projects. But they proved to be so successful that such "temporary empires," or dedicated studio spaces, now exist all over the company.

The first studio space at IDEO was built in 1995 when Dennis and his team were working with Palm Computing to design the Palm V handheld computer. They found that sitting together had incredible benefits. It increased the energy around the project, enhanced communication between team members, and created a place for all the project artifacts to be in plain sight. In this setup the team was always "in a meeting," making collaboration easier. Proximity is clearly an important variable when designing space. You have a very different relationship with those who work near you than with those who are far away. Studies have shown that if someone works more than fifty feet away, your collaboration and

communication is comparable to that of workers who are in different buildings.

By accident, I discovered how powerfully space can contribute to creative problem solving. I was running a simulation game in my creativity class and had divided the room into two ecosystems, so that two completely different games were going on at once. Each ecosystem had four teams, each of which challenged to complete a jigsaw puzzle in the shortest time. For each ecosystem I mixed together three one-hundred-piece jigsaw puzzles and then redistributed one-fourth of the total pieces to each team. Since there were fewer puzzles than there were teams, they had to figure out how to get all the pieces they needed from the other teams in their ecosystem in order to be successful.

One ecosystem was set up on one side of the room with a small table for each team, but no chairs. The other ecosystem was set up on the other side of the room with chairs for each team, but no tables. The first time I did this, the arrangement of the team spaces was not intended as a variable in the simulation, but just a way to differentiate the two ecosystems. However, this ended up being *the key variable* that affected the outcome of the game.

Remarkably, the students in the ecosystem on the side of the room with the chairs (but no tables) almost instantly started to collaborate with one another. Within minutes, the chairs were rearranged into one large circle or pushed aside altogether, as they worked on the puzzles on the floor. They figured out that by working together, they earned the maximum number of points for the game. On the other hand, the teams on the side of the room with tables (but no chairs) all anchored themselves to their

respective tables. They did not collaborate at all and thus ended up limiting the number of points each team earned.

Since the tables in the room have wheels and move easily, it would have been a trivial matter to push them together to create one big team. However, in the dozens of times I have run this exercise, this *never* happens. The participants are always shocked when I point this out to them. They think that they have been making well-thought-out strategic decisions and are blown away by the realization that the space literally dictated what they would do.

Essentially, those on the side of the room with the tables see their world as framed by the tables in front of each team, and therefore they don't even consider moving them. A key take-away from this exercise is that space dramatically affects team dynamics and creativity. The participants never imagined how important this variable would be in changing their behavior. The space told a powerful story, and each team dutifully placed itself inside that narrative. On the side of the room with the tables, the story line is "This table is our kingdom. It is up to us to build and protect it." On the side of the room with the chairs, the story line is "Our world is very flexible. With little effort we can reorganize the way we work together."

No variable should be overlooked when designing a creative space, including the color of the walls or the music played in the background. Recent studies suggest that red walls help you focus your attention, while blue walls foster creative thinking. The explanation is that blue conjures up images of the sky and thus opens up your mind. This is consistent with the finding that people have

more expansive ideas when outside or in spaces with high ceilings. Architects talk about the importance of inaccessible spaces inside a building. These are spaces that you can see but cannot access. Even though you can't touch the ceiling, you are profoundly affected by its height. Consider the fact that traditional churches and concert halls usually have extremely high ceilings. They are designed to encourage lofty thoughts and feelings.

We are also influenced not just by what is in our space, but by what we see outside our windows. Whether you are looking at a wall of buildings or an expanse of trees dramatically influences how you feel. A 1984 study shows that hospital patients recover at different rates depending on the view outside their window. Researchers at a suburban Pennsylvania hospital found that twenty-three surgical patients who had rooms with windows that looked out on a natural scene had significantly shorter postoperative hospital stays and took fewer painkillers than twenty-three similar patients who were in rooms with windows that faced a building.[2]

Ambient sound also has a huge impact on how we feel. In fact, our entire life has a sound track, just like a movie. If you change the sound track, the feeling of the scene changes dramatically. Ori Brafman, the coauthor of *Click*, provided a provocative example in a lecture he gave at Stanford.[3] He showed a short video of someone skiing down a startlingly steep mountain with pounding rock music in the background. The skier's experience looks terrifying and exhilarating. Ori then played the same video clip again with melodic classical music in the background. The experience was instantly transformed. Now the skier appeared to be floating down the cliffs in a calm and meditative manner. The sound track was a primary character in the video cueing us to feel either exhilarated or serene.

I tried a similar experiment by using a classic scene from the movie *Rocky* in which Rocky Balboa is training for a big fight. The original score has bold music that foreshadows Rocky's future triumph, winning against all odds. I created a new version in which the same training scenes are accompanied by a slow, sad version of the same music. This caused the mood to shift 180 degrees. Rocky looks like a doomed failure rather than a hero with the melancholy music. His winces of pain look like fatal flaws rather than signs of strength and endurance. Of course, this tool is used in every movie or TV program we watch. The laugh tracks in comedies cue us when something is supposed to be funny, just as ominous music alerts us to impending danger in horror films.

Sound tracks don't influence only how we feel, but also our sense of taste. A study by Adrian North, in the United Kingdom, demonstrated that the way we experience wine changes significantly depending on the music in the background. In this study, participants were given both red and white wine and were asked to fill out a survey about their taste. The background music was different in each tasting. The selected music could be described as heavy, subtle and refined, light and refreshing, or mellow and soft. The survey results showed that subjects' experience of the wine matched the music in the background. In effect, the background music literally changed the taste of the wine![4]

Ewan McIntosh, who is an international expert on learning and technology, spends considerable time thinking about learning spaces. He describes seven different types of spaces that can exist in both the physical and the online world. Based upon prior work by Matt Locke, Ewan describes how different types of spaces dra-

matically change how we interact with one another.[5] If you are hoping to create spaces optimized for innovation, it is helpful to consider all of these types of spaces.

The first type of space is "private space." We each need to find places where we can be by ourselves for some part of the day. If we aren't given these spaces explicitly, in the form of private offices, we create them ourselves. For some people, this involves finding a quiet spot for a private phone call. For kids in school, it might mean carving out a small space on a public bench and pulling their knees up, thus creating a private space for text messaging with their friends.

Second are "group spaces," where small teams of people can work together. This might seem obvious, but so many classrooms and offices are designed to prevent this type of team interaction. We sit in rows in a lecture hall or are isolated from one another at desks that don't move or in offices that are outfitted with small cubicles. Group spaces are important, because they provide the opportunity for intense collaboration. In a home, this is often the kitchen table, where everyone gathers to share what is going on and to discuss topics of mutual interest.

Third, "publishing spaces" are designed to showcase what is going on. These occur in both the physical and the virtual world. In the virtual world publishing takes place on websites where we share our photos and videos that reflect what we have done and where we have been. In the physical world, the items displayed in the public rooms of your home, such as artwork, pictures, and souvenirs, tell visitors about you. In addition, your refrigerator and bulletin board, covered with notes and pictures, are prime examples of publishing spaces. In an office, this kind of space is often overlooked by management, leaving it to individuals to fill their cubes or offices with memorabilia. These artifacts serve

both as reminders of what has happened and as stimulants for future creative endeavors.

Fourth, "performing spaces" are those where you can either share your ideas or act them out. These spaces stimulate your imagination and help bring ideas to life. They don't have to be permanent spaces, but they should be available when needed. For example, if the furniture can be moved out of the way, any room can be turned into a performance space when it is time to share ideas.

Fifth are "participation spaces." These are essentially places that allow personal engagement with what is going on. For example, Ewan suggests, if you turn a schoolyard into a public garden where students tend the plants, it is transformed from a group space into a participation space. Or if you make employees aware of their energy usage by showing real-time data about how much is being consumed, then their behavior in the space naturally changes. They become participants in the space rather than mere occupants.

The sixth type of space is for "data." This is like a library or database, where we archive information that will be needed later. It isn't necessarily in a public place, but it needs to be easily available, either physically or online. As more and more information becomes available online, we need to consider how that space affects the way we work. In the past, people would pore through reference books in the library to get the material they needed. Now a large percentage of us are plugged into the Web a good part of the day, since that is where we can most readily find the data we need.

Finally, there are "watching spaces," which allow us to passively observe what is happening around us. Sometimes we want or need to be passive observers, watching and listening to what is going on rather than being active participants. By watching

we get meaningful information about the activity in our environment, which allows each of us to feel more connected to the organization.

Creative spaces lead to creative work. Pixar, the company behind mind-bendingly creative movies such as *Toy Story* and *Finding Nemo,* provides a terrific example. Large characters from Pixar movies greet you as you enter, and each designer is encouraged to create a space that reflects his or her passions. As a result, there is an office that looks like a gingerbread house, one that is designed like a tiki hut, and another that is a Lego castle. Rest assured, this is not just for fun. There is no way that the designers at Pixar would be able to come up with such innovative products without such a rich and provocative environment.

You don't need to be a hugely successful media studio to have a stimulating space. Many start-up companies adopt this philosophy. Not only does it lead to more creative work, but it also helps attract and retain employees who are eager to work in such an environment. Scribd is a great example. Run by Trip Adler, Scribd is an online publishing platform with a large open office with high ceilings. It has a zip line that runs down the length of the space; a collection of go-carts, pogo sticks, nerf guns, skateboards, unicycles, and scooters; a karaoke machine; a pool table; and a ping-pong table. Employees who refer a new employee to the company get a plaque next to their "toy" with their name on it. They even invented a new go-cart game called "scracing," a combination of "Scribd" and "racing." Trip says that this new game has pushed the company's creativity to new levels. They certainly don't play all day long, but the playful artifacts and games are reminders that they are encouraged to be creative in all they do.

Despite the importance of space to innovation, it is still just a shell for the people inside. As a result, it is equally important to consider *who* is in your space. Each person in your environment affects the culture and influences the topics that are discussed. This doesn't just apply to the people with whom you work directly, but also to the people you bump into when walking around the building. In fact, the random connections between people in the hallways play a big role in determining what happens in your space. This echoes Rory McDonald's research, referenced earlier, on parallel "play" in business. He is studying how adults, just like young children, are deeply influenced by those around them even if they are not actively engaged with one another.

Space is a key factor in each of our habitats, because it clearly communicates what you should and shouldn't be doing. If you live and work in an environment that is stimulating, then your mind is open to fresh, new ideas. If, however, the environment is dull and confining, then your creativity is stifled. Just as Liz Gerber encouraged those in her workshop to do, consider rearranging the furniture, picking up a paintbrush, filling your room with art and artifacts, or even plugging in an electric screwdriver to build a space that enhances creativity.

Space is the stage on which we play out our lives. If you want to be creative, you need to build physical habitats that unlock your imagination.

SIX

THINK OF COCONUTS

Over a year ago, my editor, Gideon, called to tell me that HarperOne wanted to publish this book. He was delighted to tell me that I had ten months to complete the project. My previous book, *What I Wish I Knew When I Was 20,* had been on a four-month crunch schedule. At first, the new book's deadline seemed very civilized. However, I kept procrastinating until I had only four months left. Each day that I put off writing surprised me. I knew that I would get the book done and was enthusiastic about the process. So why was I putting it off day after day?

I eventually realized that I was putting off writing on purpose. It was creative procrastination! Essentially, I was building up my creative pressure. By giving me more time, Gideon was removing an important stimulus to my creativity. So, without consciously knowing it, I added it myself.

As an educator, I should have known this would happen. My students do the very same thing. If given an assignment that is due in ten weeks, they wait until the eighth week to get started. In fact, I used to assign one long-term project in my class, but finally threw that out in favor of assigning three two-week proj-

ects. The results have been astounding. The students have three times more work to do, but they do a much better job and enjoy it much more. The pressure is there from the start, and their energy never wanes, since there is no time to waste. Constraints of all types play an important role in creative output. As Marissa Mayer, head of product development at Google, says, "Creativity loves constraints."[1] And time is one of many powerful examples.

Teresa Amabile, Constance Hadley, and Steve Kramer, at Harvard Business School, describe this concept beautifully. They have been studying creativity in organizations for many years. In an article called "Creativity Under the Gun,"[2] Amabile and her colleagues show how pressure in general influences creativity in this two-by-two matrix:

	Low Pressure	High Pressure
High Creativity	EXPEDITION	MISSION
Low Creativity	AUTOPILOT	TREADMILL

There are conditions under which people experience low pressure and high creativity. They feel as though they are on an *expedition* because they are free to engage in unfettered exploration of opportunities. In this situation individuals need to be very self-motivated and inspired in order to use this stress-free time for creative endeavors.

There are other instances of low pressure that lead to low creativity. In these cases individuals feel as though they are on *autopilot*. There are no external incentives or encouragement to be creative, and they are both bored and uninspired.

Sometimes high pressure leads to low creativity. This occurs when the pressure is unrelenting and unfocused. Work feels unimportant, and the goals keep changing. Individuals in this situation feel as though they are on a *treadmill* that never stops.

Finally, there are conditions where high pressure leads to high creativity, and people feel as though they are on a *mission*. In this environment, despite the pressure, there is a clear, focused, and important goal, and people are highly creative. An extreme example of being on a mission occurred during the Apollo 13 disaster in 1970. Amabile and her colleagues describe this well in their paper:

In 1970, during Apollo 13's flight to the moon, a crippling explosion occurred on board, damaging the air filtration system, and leading to a dangerous buildup of carbon dioxide in the cabin. If the system could not be fixed or replaced, the astronauts would be dead within a few hours. Back at NASA mission control in Houston, virtually all engineers, scientists, and technicians immediately focused their attention on the problem. Working with a set of materials identical to those on board the spaceship, they desperately tried to build a filtration system that the astronauts might be able to replicate. Every conceivable material was considered, including the cover of the flight procedure manual. With little time to spare, they came up with something that was ugly, inelegant, and far from perfect, but that seemed like it just might do the job. The

engineers quickly conveyed the design with enough clar-
ity that the cognitively impaired astronauts were, almost
unbelievably, able to build the filter. It worked, and three
lives were saved.

Clearly, in this situation, everyone involved had extraordinarily
high pressure and greatly enhanced creativity. They had limited
time and limited resources, and lives were literally on the line.
The stakes may be different, but this type of rush happens all
the time when we race to pull together a last-minute event with a
moment's notice or when we sprint to get a product out the door
before a hard deadline.

That sort of sprint happened at eBay after the tragic events on
September 11, 2001, when terrorists destroyed the World Trade
Center in New York City. The company decided to launch an "Auc-
tion for America" with the goal of selling donated items to raise
$100 million in one hundred days. The effort to plan and build
this product would have normally taken twenty weeks to accom-
plish. However, given the circumstances, there were only three
days—one day to design the site and two days to code and test it.
One hundred of eBay's engineers were assigned to the project. They
worked around the clock over an entire weekend, getting the job
done with only one hour to spare. The members of the team all felt
that they were on a mission, with a focused and important goal.
This is a powerful reminder of what can be accomplished when
there is an emergency that requires quick and creative thinking.[3]

We can tap into the insights from these extreme experiences
to see how constraints in all habitats stimulate creativity. Let's
consider start-up ventures. In most cases these young businesses
have limited resources and need to bring a product to market

very quickly. For most start-ups, these constraints are actually a good thing and a catalyst for creativity.

Ann Miura-Ko, a partner at Floodgate Fund, echoes this sentiment. She strongly believes that constraints are necessary for all companies, especially start-ups. Without them, companies pursue failing strategies and are much less creative in finding ways to reach their goals. With severely limited resources, company founders need to make painful trade-offs and must find creative ways of solving their problems. They have to sacrifice things they *want* to do in order to do the things they *need* to do. Constraints force them to be thoughtful, to prioritize, and to be as innovative as possible.

A memorable example comes from Monte Python's movie *Monte Python and the Holy Grail*. In a scene in this low-budget movie you hear horses coming toward you through a thick fog. As they get closer, you realize that there are no horses—just a soldier banging two coconuts together to sound like the clopping of horses' hooves. The budget was so low that they couldn't afford horses. As an alternative, the actors decided to bang two coconut shells together to create the sound. The scene, which would have worked with horses, is so much funnier with coconuts instead. This is a poignant reminder that less is often more. In addition, it echoes the message about framing problems. By asking the question "How can we re-create the sound of horses," as opposed to "How do we get horses," the range of solutions shifts dramatically. Whenever you are in a situation with severe constraints, think of coconuts for inspiration!

This idea is reflected in Eric Ries's work on "lean start-ups."[4] He developed this approach during his tenure as cofounder and technical lead at IMVU, a successful online gaming company.

Through this experience he learned that working with forced constraints leads to better products. The "lean start-up" philosophy advocates the creation of rapid prototypes of products to test-market assumptions by releasing a "minimum viable product." By spending the smallest amount of time and money you can on a new product before it is released, you end up with much faster customer feedback. This allows you to develop and improve your products much more quickly than when you use traditional engineering practices. This approach has taken off like wildfire as companies realize that even when developing complicated technical products, less is often more.

To demonstrate this concept in my creativity class, I ask students to create an entire line of greeting cards in thirty minutes. As you can imagine, a company would normally take months to accomplish this task. I assign the students a specific holiday and set them loose with nothing more than paper, markers, and scissors. At the end of the allotted time, they need to display prototypes of four cards that will be sold together and to give a sales pitch. The entire class votes on their favorite designs and the winning team gets a prize. This means that they all have extremely limited time, limited resources, and competition.

The results are always entertaining and inventive. For example, when the assigned holiday was Earth Day, one team created cards embedded with seeds that could be planted after the cards were read, and another team made cards that were to be passed on to others with added messages in order to save paper. The students are always delighted by what they accomplish in a remarkably short period of time and admit that the pressure was a surprising catalyst.

. . .

There are many real-life situations in which imposing severe constraints leads to an outpouring of creativity. Twitter is a terrific example. With only 140 characters to get your message across, you need great restraint and ingenuity to put together a headline that grabs your audience's attention. This initially seems terribly limiting—and it is. But over time, people have found remarkably innovative ways to use it. As a Twitter user, I often strategize about how to describe what I am doing or seeing in so few characters. Like a haiku or a tiny blank canvas, it requires laser-focused attention and creativity to communicate anything meaningful.

Here are a few of my favorite examples. By following @cook-book, written by Maureen Evans, you will get recipes that are only 140 characters long, such as the following:

Roast Snow Pea & Grapefruit Salad: zest,dice grapefruit; mix juice+t lem&honey&sesoil. Toss lb pea/t sesoil/¼t zest&s+p; broil~3m. Toss all.

Eggs Berlin: 3c shallot/⅓c olvoil h@low; +6c zuke 20m@ low to tender; +¼t thyme/lem&garlc/s+p. Top 4pce pumpernickel tst; +4poachedegg/basil.

Caesar Salad: Mince6anchovyfillet/garlc; +t grndmustard/½c olvoil. Whisk+egg/lemon. Toss+lrg romaine/½c parm/3c crouton; +lem/s+p to taste.

Another Twitter user, Jonah Peretti, came up with a way to create a "Choose Your Own Twitter Adventure." It is totally brilliant. Here is an example:

Choose Your Own Twitter Adventure! RT so your followers can play! Good luck! =>/http://bit.ly/ Start-The-Adventure

You're assigned a dangerous mission to save the world! Do you 1) http://bit.ly/Accept-Mission or 2) http://bit.ly/Go-On-Vacation

You parachute to North Korea sneak past guards to a live nuclear bomb. Do you 1) http://bit.ly/Cut-Red-Wire 2) http://bit.ly/Cut-Blue-Wire

Cutting the blue wire begins a chain reaction— omg that is bad. Like really bad. =>/http://bit.ly/ Do-You-Survive

Your life flashes before your eyes as you die. What could you have done differently? Try again =>/http://bit .ly/play-again

But what if the constraints are even tighter? How about six words? Apparently Ernest Hemingway was once asked if he could write his memoir in only six words. He responded with the following sad tale: "For sale: baby shoes, never worn." This challenge was embraced by *SMITH* magazine, which, in turn, has offered it to everyone via its website, out of which has become a bestselling book.[5] It is amazing how creative and illuminating six words can be. Here are a few examples from the website:

Stuck on repeat. Stuck on repeat.

I was engaged for one day.

I am disabled, but not helpless.

Found on CraigsList, table, apartment, fiancé.

Hobby became job. Seeking new hobby.

I'm not lazy. I'm pacing myself.

I'm the careless man's careful daughter.

To stimulate the students' imagination and get to know them on the first day of our creativity course, we asked them to introduce themselves to each other using their own six-word memoir. The severe limitations produced interesting results. Here are some samples:

My greatest ideas involve duct tape.

Corpses no longer follow me home.

Two eyes open, but still nearsighted.

I never turn down a dare.

In some cases there is great benefit to taking the opposite approach: removing all the constraints, or taking them away one by one. According to Diego Piacentini, the head of international business operations at Amazon, Amazon's directors often remove the financial constraints when making a business decision. They ask whether they would make a specific business decision in favor of customers if there were no financial consequences. If the answer is yes, then they figure out how to make the solution work, even if the decision doesn't make sense from a financial perspective in the short term.

For example, before 2002, Amazon offered free shipping of its products during the holidays, but not during the rest of the year. It was clear that customers loved this offer and purchased more products when they didn't need to pay for shipping. On first inspection, there was no way the company would be able to offer this benefit year-round, because shipping is expensive, and giving it away for free eats into profits. But the Amazon leadership team asked themselves if this is something they would do if there were no financial constraints. The clear answer was yes. So they figured out how to make it work. By finding ways to increase the volume of their shipments, they were ultimately able to negotiate for lower shipping prices, which made this decision pay off for everyone.

Every habitat has its own constraints. They include some combination of time, money, space, people, and competition. These constraints sharpen your imagination and enhance innovation. Even when you have an abundance of resources, it is valuable to consider how you would tackle the same challenges without them. Constraints are a tool that can and should be modulated up and down to catalyze and compound creative energy.

MOVE THE CAT FOOD

On cross-country car trips with my family when I was young, my parents entertained my two siblings and me by playing typical car games. One involved looking for license plates from different states; another dealt with identifying mystery objects in the landscape; and a third required us to find everything we could that started with successive letters of the alphabet, from A to Z. These formal games complement the games that are literally built into our lives. Every family has its rules, as does every classroom, every office, and every social group. As such, each environment can be considered a game. The rules—as well as the rewards and punishments—of each of these "games" are an integral part of each of these environments and dramatically influence our behavior.

We are naturally tuned to rules and quickly learn the subtle differences between the varying expectations in each habitat. Therefore, if you want to enhance your creativity, and that of those with whom you live and work, you need to employ rules and rewards that encourage innovation. Just as you can manipulate your space and the constraints in your environment to tune

up your Innovation Engine, you can also change the rules and rewards to inspire more creativity.

Because of the large and growing popularity of video games, some researchers have become experts on the subtlety of games and their effects on behavior. Their insights have been used to design rules for many other environments that are crafted to influence people's behavior. This is known as "gamification."

Tom Chatfield, of the University of Bristol, studies gamification and has come up with a list of several factors that inspire people to engage in desired behaviors.[1] Based on a collection of psychological principles that are easily generalized to apply to any organization, these are important variables to consider when you hope to inspire creativity.

First, Chatfield describes the need to give individuals both accurate and frequent feedback about their progress in any game. This means providing data about how they are doing in tiny increments. For example, in most video games players are able to see their scores at all times, giving them rapid feedback about when they are doing well or slipping behind. Points add up quickly for small improvements, and that way players rapidly learn what works and what doesn't. The massive success of games such as Angry Birds, which is currently downloaded over a million times each day, demonstrates this well. Each round of play is only a few seconds long and provides instant feedback. A player can quickly and easily experiment with different approaches in order to develop winning strategies.

The same principle has been used in electric cars, which have a dashboard display showing drivers exactly how efficiently they are driving. This instant feedback turns driving into a game, as drivers modify their driving to get the best "score." Joe Nocera describes test-driving a Chevy Volt for a few days:

Here's what really got me, though: on the dashboard, alongside the gauge that measures the battery life, the Volt has another gauge that calculates the vehicle's miles per gallon. During the two-hour drive to Southampton, I used two gallons of gas, a quarter of the tank. Thus, when I drove into the driveway, it read 50 miles per gallon.

The next day, after the overnight charge, I didn't use any gas. After driving around 30 miles in the morning, I recharged it for a few hours while I puttered around the house. . . . That gave the battery 10 miles, more than enough to get me where I needed to go that evening on battery power alone. Before I knew it, my miles per gallon for that tankful of gas had hit 80. By the next day it had topped 100. I soon found myself obsessed with increasing my miles per gallon—and avoiding having to buy more gas. Whenever I got home from an errand, I would recharge it, even for a few hours, just to grab a few more miles of range. I was actually in control of how much gas I consumed, and it was a powerful feeling. By the time I gave the car back to General Motors, I had driven 300 miles without using another drop of gas beyond the original two gallons. I'm not what you'd call a Sierra Club kind of guy, but I have to tell you: I was kind of proud of myself.

When I began to describe for Mr. Lutz the psychological effect the Volt had had on me, he chuckled. "Yeah," he said, "it's like playing a video game that is constantly giving you back your score."[2]

Nocera states later in the article: "Volt owners often drove 1,000 miles or more before they needed to buy gasoline." This is a tan-

gible example of how frequent feedback impacts our behavior.

Think how powerful it would be if we got this type of feedback on our behavior in all of our endeavors. For example, consider the relationship between a restaurant server and a customer. Some customers want lots of attention, and others want to be left alone. If customers had a monitor on their tables that showed how they felt and reflected how large a tip they intended to leave—essentially a "tip-o-meter"—then servers would get constant feedback on how they were doing and could modify their behavior based upon the feedback.

This type of micro-monitoring is now starting to become popular during political campaigns. During the last U.S. presidential election, CNN broadcast the debates between Barack Obama and John McCain with a moving graph on the bottom of the screen showing real-time audience reactions. Selected viewers would give positive or negative points to each candidate based upon their reaction to what was being said. The results were totaled and shown on the bottom of the screen.

The complete opposite of this approach is seen in typical company performance reviews, which are usually conducted once a year, before salaries and bonuses are calculated. Not only does this infrequent feedback result in greater stress for employees; it also diminishes creativity. With infrequent feedback, employees do what is safe and avoid taking creative risks for fear of a negative review at the end of the year. They do what they know will work rather than trying something novel. By contrast, if managers provide frequent feedback, employees have a chance to modify their behavior rapidly before deep-seated patterns and expectations are set.

At the d.school we use an approach designed to provide rapid feedback and to enhance innovation. Right after class, the teach-

ing team and the students gather to participate in an "I Like, I Wish, What If" discussion. We roll in a whiteboard and sit around in a circle. The entire group, both students and teachers, chime in with the things they liked about the class, things that could have gone better, and new ideas to try out next time. The teaching team and the students get rapid feedback and can make changes along the way rather than waiting for feedback at the end of the quarter, when it is too late to change anything. In our creativity class last quarter, we did this several times over the ten-week course. Each time there were fabulous suggestions for the faculty and the students, which we were able to implement immediately. They included a new way of assigning homework and an improved way of evaluating projects. This type of feedback is incredibly valuable and encourages everyone to experiment with new ideas, knowing that they will get quick feedback on what worked and what didn't without fear of surprising negative consequences at the end of the course.

Chatfield also describes the need to provide both short-term and long-term goals. There should be the opportunity for small wins along the way as well as large goals on the distant horizon. In the gaming world, this might involve outwitting lots of different demons on the way to slaying a daunting dragon to win the entire game. This approach works well in school or work situations, too. Individuals should be rewarded for finding solutions to small problems on the way to tackling a looming challenge or an important milestone that might be years away.

Proteus Biomedical has created a fanciful "game" to reward innovation. Whenever someone files for a patent, he or she gets a small rubber brain to add to a large apothecary jar, which is displayed on a shelf with others' jars in the entrance to each building. These brains have become a status symbol in the com-

pany, and everyone is eager to add another one to their collection. Company cofounder Mark Zdeblick has jars full of brains, with the overflow piled above his desk. This program recognizes inventors and effectively encourages innovation across the company.

A humorous example comes from a new website called *Written? Kitten!* which is designed to encourage writing. With this application, whenever you reach a specific writing target, such as three hundred or five hundred words, you are shown a new image of a kitten. For those who like cats, this is probably a great incentive to keep writing. This program was designed in response to an application called *Write or Die,* which punishes writers for *not* writing. The idea behind this application is to instill fear in the would-be writer. You can set the program to several different levels of punishment for not writing. In the gentle mode, when you stop writing for a specified amount of time, a box pops up with a friendly reminder to continue writing. In the normal mode, if you stop writing, a very unpleasant noise prods you to start writing again. And in the "kamikaze" mode, if you stop writing, the program will start to erase your written work, one word at a time, until you start again.[3]

Whether you prefer rewards for reaching specific goals or punishment for inactivity, it is important to give credit for efforts made as well as successful completion of a task. The two writing programs do this, because they don't judge your work. They only respond to the act of writing. This resonates with lessons from Robert Sutton's book *Weird Ideas That Work.*[4] Bob argues that creativity is enhanced when you reward both success *and* failure and punish inaction. Creativity, as well as gaming, has many dead ends, and people need to be rewarded for exploring and

finding out that a particular approach won't work. By actively rewarding effort, you encourage even more exploration.

Engagement and exploration are also enhanced when the process includes some uncertainty and surprise. Scientists who study animal behavior have known this for many years. The famous psychologist B. F. Skinner found that intermittent, or random, rewards lead to more robust behavior. For example, if a monkey discovers that sometimes pressing a bar produces a piece of fruit and other times it doesn't, the monkey will press the bar more consistently, knowing that sometimes the effort will pay off. This psychological principle is used all over Las Vegas, where gamblers play on the slot machines for hours, waiting for random payouts. This principle can be used to enhance creativity by giving intermittent recognition for creative work. Consider using surprise rewards for creative contributions, or randomly giving special perks for particularly innovative ideas. Knowing that at any time there could be a wonderful surprise as a reward leads to enhanced creative work.

Finally, gaming is also enhanced when there is real social engagement. We are all social animals, and the opportunity to be actively involved with others in a meaningful way inspires us to do remarkable things, pushing beyond what we would do on our own. A great example comes from running races. My son, Josh, a sprinter at the University of Southern California, confirmed that runners almost always perform better, beating their own personal records, when they run in relay races. Being part of a team motivates them to reach deep inside to pull out a stellar performance. This effect can be employed in education, in business settings, and at home. By working together, sharing successes and failures, a creative team pushes beyond the limits inherent in working alone.

. . .

It is also clear that you can make all types of activities more engaging by turning them into a game. An initiative run by Volkswagen, called "Fun Theory," is dedicated to making everyday chores such as walking up the stairs or throwing away trash into entertaining activities. For example, at a subway station in Sweden there are both stairs and an escalator heading out of the station. The majority of people take the escalator. The Fun Theory folks decided to make walking up the stairs much more fun than taking the escalator. They did this by turning the stairs into a piano keyboard. When you walk up the stairs, you make music. Almost everyone passed up the escalator in favor of running, jumping, and dancing up the stairs, because it was fun and entertaining. The Fun Theory Team also created the "world's deepest trash bin" in a public park. When you throw in a piece of paper or bottle top, there is a loud sound effect that makes it appear as though the object is falling hundreds of feet before crashing at the bottom. It is so much fun that people start collecting trash around the park so they can hear this surprising sound.[5]

Games are a great way to demonstrate that small changes in the rules have a big impact on creative behavior. In one of my classes, I picked a game that has a clear balance of rules and rewards, so we could determine if changing that balance has an effect on creativity. I decided to use Scrabble, a game almost everyone in the United States knows. Each player randomly picks seven letters from a bag. Players have to create words using those letters by placing them on a board, building on another word that has already been placed on the board. The Scrabble board is very structured, and clear incentives are in place. Players are encouraged to build out from the center, stretching toward the edges of the board so that they can reach the squares that earn a triple

letter or, ultimately, a triple-word score along the edges. Along the way, players are rewarded with smaller, but still valuable, bonuses, such as double-letter and double-word scores. And there is a big fifty-point bonus for using all seven letters at a time.

I brought eight Scrabble boards to class and let the students play. Once they settled in, every ten minutes I changed the rules of the game. Some of the new rules loosened the guidelines, and some tightened them up. For example, to loosen the rules, I allowed players to pick nine letters instead of seven, to use proper names, or to use foreign words. To tighten the rules, I required players to add only four-letter words, to build each new word onto the prior word only, or to add a word to the board within a certain time limit.

The results were quite surprising. As expected, whenever I loosened the rules, there was an audible cheer, and when I tightened the rules, the students groaned. But the cheers were misleading. You would think that the players would score more points and be more creative when the rules were looser. However, that was not the case. The students were more creative—and earned more points—when they had tighter rules. For example, when the rules were loosened to include proper names, one student put down a jumble of letters and claimed this was the name of her future child. Although it was funny, all agreed that this was a sloppy response rather than a creative solution. When the rules tightened up, the students had to be more creative *and* the competition around the board broke down. They had to work together to reach their individual goals. In the end, they collectively earned more points. This reinforces the message in the previous chapter on the impact of constraints on creativity.

During the discussion that followed the game, the students all felt that the original Scrabble rules provide the perfect balance

between constraints and freedom, and that's why the game has thrived so long. But they also realized that changing the rules just a small amount drastically changed their experience. They walked away with a new appreciation for the sensitive levers they have at their disposal when they manage or are part of creative teams. They realized that they should fully appreciate the goals they have in mind and put rules and incentives in place to inspire others to reach them.

These concepts are relevant in all ventures. For example, the U.S. Food and Drug Administration (FDA), the government agency responsible for determining which devices and drugs are safe and effective, implements incentives dictated by Congress to encourage drug companies to behave in specific ways. Most drug companies develop medicines for diseases that affect a large number of people, since they are motivated to sell a large volume of the drugs they develop. This makes sense, since it costs an enormous amount to invent, test, market, and distribute a new medical product.

Nancy Isaac, a lawyer who specializes in helping drug companies bring their products to market, explained that the government also wants to encourage drug manufacturers to create medicines to treat rare diseases, also known as "orphan drugs." In order to provide incentives, drug companies that develop orphan drugs can receive special privileges. One notable incentive is that instead of two to three years of exclusivity, during which the originator of the drug is the only company that can sell it, companies that develop orphan drugs are given seven years of exclusivity. This allows them to sell the medicine without any competition for seven years, which is a huge incentive. This has

led to an entire industry of drug companies that specialize in making drugs for rare diseases.

The Orphan Drug Act worked so well that children's advocacy groups are pushing Congress to add yet another twist. They want drug companies to focus on orphan drugs for diseases that affect children, so they propose an additional reward. If a company creates an orphan drug for the pediatric market, it would not only get seven years of exclusivity; it would also receive a voucher, or ticket, that allows it to go to the front of the FDA approval line when it develops its next drug. This voucher is incredibly valuable, since there is usually a long wait to get approval for a new drug. In addition, vouchers could be sold. So if a company creates an orphan drug for a rare childhood disease, it can use the voucher itself or sell it to another company that wants to jump to the front of the approval line. Big drug companies would be willing to pay millions of dollars for this privilege, which would mean a huge profit for the drug company that sold the voucher. This is a wonderful example of using rewards to stimulate creative problem solving.

In other cases the FDA has rules in place that appear to inhibit innovation. One person who has taken on the challenge of trying to improve medical innovation in the United States by changing these policies is Josh Makower. Josh is a physician, engineer, and serial entrepreneur who has started several successful medical technology businesses. Josh is concerned that the current situation at the FDA is seriously threatening the evolution of the next generation of medical devices, such as stents, artificial joints, and implanted devices that can help with illnesses as diverse as migraine headaches or menstrual cramps.

Right now, there is a daunting array of restrictions on testing and adoption of these new devices. For example, because of

conflict-of-interest concerns, the FDA puts significant restrictions on the way physicians can test medical technology inventions. In addition, the FDA officials who make the decisions about which devices are approved receive no rewards for approving successful innovations, but do risk punishment if a device they approve later has problems. As a result, FDA officials are much more likely to deny approval of new innovations, and most new medical technology devices that are invented in the United States are released internationally long before they are available in the U.S.

Many leading medical technology inventors, such as Josh Makower, are working hard to encourage the FDA to achieve an appropriate balance between safety and innovation, so that the pipeline to the marketplace is much smoother for new medical technology products. Lately, Josh has spent a good part of his time talking with leaders at the FDA and in Congress, encouraging them to change their rules and rewards related to medical technology regulation.

There are many places where rules are put in place that are designed to improve performance that turn out to inhibit innovation. A poignant example was showcased on the radio program *This American Life*, hosted by Ira Glass. In a 2004 episode, Ira Glass follows an inner-city elementary-school teacher, Cathy La Luz, in Chicago over a span of ten years.[6] She was the most inspiring teacher Ira Glass had ever met when he was covering education for Chicago Public Radio in 1993. She loved her second-grade students, and they adored her. However, ten years later, she was planning to quit. Ira Glass went back to the school to see what had happened. He compared the school in 1994 to the same school in 2004. The differences were astounding.

In 1994, Washington Irving Elementary School was a model school. It didn't have much money, but its administrators did have a plan. They wanted the kids to want to come to school and to enjoy learning. To achieve this, they gave the teachers a lot of autonomy and control over their classrooms. Teachers like Cathy La Luz had a chance to be as creative as they could be in order to help the students learn to read and write. They had frequent meetings with each student's parents and were able to build strong bonds with the kids. The teachers and the students were happy with the freedom they had to experiment and learn together. The students were eager to learn and were happy to be at school.

However, over a nine-month period, ten years later, this successful strategy fell in ruins. A new principal came to the school and started instituting rules that were designed to increase accountability, but that in fact shattered the creative environment that motivated the teachers and the students. For example, new rules required the teachers to craft detailed lesson plans for each day and to write the specific learning goals on the board before each class, complete with references to specific curriculum guidelines. The positive environment at the school collapsed under the weight of all these constraints and guidelines, and terrific teachers such as Cathy La Luz cried as they debated leaving education altogether.

This situation is all too common. Many rules are designed with the goal of improving performance, but they actually do the opposite. They are often controlling and certainly stifle creativity. Therefore, you need to be extremely aware of the consequences of each rule you put in place. We are so sensitive to rules that even small changes have a huge impact on our behavior.

Consider the entire process of applying to college. Prospec-

tive students know exactly what schools are looking for and craft their lives around these expectations. In the United States, students know that schools look at their grades and standardized test scores and expect them to have a long list of extracurricular activities. Therefore, students spend years creating a portfolio of activities and cram for exams in order to match the profile of the perfect candidate. Many students even hire coaches to help them craft a plan to market themselves to schools.

On the flip side, universities and colleges have their own report cards. They get a higher ranking if lots of students apply, if they accept a very small percentage of those applicants, and if a high percentage of the students they admit decide to accept the offer to attend. This is known as their "yield." Therefore, colleges and universities actively market themselves, trying to get as many applicants as possible. As a result, more students apply, the odds of getting in decreases, and students are driven to apply to even more schools. Everyone in this ecosystem knows the rules and the rewards, and they change their behavior to maximize the things that are measured.

In other countries the college admissions process is quite different, and prospective students respond accordingly. For example, in Chile, students take an exam that is offered only one day each year. Their score is the only determinant in evaluating the students. All the students who take the exam are ranked in order, and the students themselves get to select which university they will attend, with the top-scoring students getting the first pick. Prospective students focus only on this one exam, since this is the one variable that matters, and a high score gives them the chance to select the school they wish to attend.

In all environments, you get what you reward. As Jim Plummer, the dean of Stanford School of Engineering, says, "Leading

university faculty is like herding cats, and part of my job is to move the cat food to support our strategic plans." He puts incentives in place to encourage the faculty to engage in activities that support broader university goals than individual faculty by themselves might choose to pursue. For example, it is important that faculty reinvent themselves on a regular basis by launching brand-new research initiatives. One of the ways that Dean Plummer encourages faculty to do this is by offering seed funding to those who want to explore uncharted research areas. This incentive results in exciting new research initiatives, many of which would not have happened without this enticement.

If you want individuals to be creative, then you need to design a habitat in which the incentives are aligned with that goal. If you want teams to come up with new ideas, then you need to provide them with feedback that demonstrates that creativity is valued. If you want your organization to push beyond obvious answers, then you need to understand that all of life is a game, and you should craft the rules that reward ingenious solutions to both short-term and long-term goals.

MARSHMALLOW ON TOP

If you plan to climb to the top of Mt. Everest, you will find there is a formula for this type of expedition. It literally takes a month of preparation, as a large team sets up several camps along the path up the mountain. They take many trips up to progressively higher altitudes to set up camps, and then come back down again, as they slowly adjust to the incredibly high elevations. At the bottom of the mountain is base camp with four tons of equipment, including tents, sleeping bags, food, oxygen, and fuel. Three other camps, each one closer to the summit, have progressively less equipment. The fourth and final camp is designed for a short stay by only a handful of people who are prepared to make the final climb to the top of the mountain. In most cases the entire team consists of about ten climbers and five trained sherpas, who carry a large portion of the equipment. Once all the camps are set, only a couple of climbers and one or two sherpas climb all the way to the top of the mountain and claim success for the entire team. This process has been repeated hundreds of times by mountaineers from around the world and is the basis for expeditions into all types of extreme environments.

But is there a different way to do this? That was the question

faced by Rodrigo Jordan, the first Latin American to summit Mt. Everest. As an experienced climber, Rodrigo was leading an expedition to the top of Mt. Lhotse, which is right next to Mt. Everest. This challenging mountain is 8,516 meters high, only a few hundred meters lower than its neighbor Mt. Everest, which is 8,848 meters high. When he and his team finished preparing all the camps for the final attempt on the summit, they had a critical question to answer: Who was going to make the final push to the top?

In most cases that question has an obvious answer. The strongest climbers get the opportunity to make that final trek. But Rodrigo got word from his team's doctor that all the climbers and all the sherpas were fit enough to make the attempt. In addition, all were eager to go to the summit. The team consisted of those who had climbed to the top of Everest before and those who were climbing in the Himalayas for the first time. It included those who were unlikely to make this climb again and those who were likely to have another opportunity. The fact that they were all enthusiastic and able to make the final journey to the summit was incredibly unusual.

As the leader, it was up to Rodrigo to decide who would make the journey. He decided to do something that he had never done before, and something rarely done by those who lead these challenging expeditions. He called all those on the expedition together and asked them what they thought. Who did they think should get the opportunity to hike to the top? After a long debate in which they weighed the pros and cons of including each of the climbers, one of the youngest members of the team, Eugenio Guzmán, known to all as Kiko, had a wild idea. He suggested that they *all* go to the summit. This was a radical suggestion. Since the climb to the summit is so dangerous, each

additional person on the ascent adds considerable risk for the entire group. Rodrigo knew this well. On a prior trek to the top of Everest, he had lost a dear friend who died on the ascent. But he was willing to listen.

After discussing how this could work from a logistical perspective, Rodrigo made the bold decision to give all fifteen climbers and sherpas the opportunity to go to the summit. One team would climb to the summit one day, and the second team would follow the next. Despite his initial confidence in this decision, after the first team made it to the summit, Rodrigo questioned his choice. He could easily abort the second trip and claim victory for this mission. Rodrigo did another assessment of the situation and decided to continue with the plan. He personally waited at the fourth camp as the second team successfully made its way to the summit and back down again.

Rodrigo is a remarkable leader in that he is always thinking about the entire team and assessing how each contributes to the success of the whole group, including the climbers and the sherpas who are usually considered the support staff for the mountaineers who have come from far away to climb. Being able to extract the most out of your teams, as a participant or a team leader, results in higher morale and vastly increases both productivity and creativity. But creating habitats where this happens is much easier said than done.

Everyone brings very different personal perspectives, working styles, and goals to any group. Also, we often think we know what we want from our team members until we get into a challenging situation and realize that the necessary temperament and skills are quite different from those that are valued during more tranquil times. Rodrigo Jordan asked a psychologist to perform a survey of his climbing team both before and after the ascent up

Mt. Lhotse. To his surprise, the list of climbers who inspired the most confidence before the climb was quite different from the one after it. This is a powerful reminder that you need to fully understand the people on your team and to anticipate how they will behave under a vast array of circumstances.

Since I don't have the time or resources to take my students to the Himalayas to test their team dynamics under extreme pressure, I had to find an alternate way to demonstrate the importance of working together as an effective team. Fortunately, there is a computer-based game designed by Harvard Business School that simulates a climb to the top of Mt. Everest. There are five people on each team, and their goal is to make the climb to the top of the mountain, reaching five different camps, or checkpoints, along the way. Each team in this simulation is composed of the leader, a doctor, a photographer, an environmentalist, and a marathon runner.

At each checkpoint on the way to the top of Mt. Everest, the participants need to assess a number of important variables, including their health, the weather forecast, and the number of supplies they have left. They also encounter several unexpected challenges, such as severe weather and medical emergencies. Many decisions need to be made at each stage, including how to distribute the limited resources and whether certain players should be left behind when they are struggling to keep up with the group. In addition, as in everyday life, each player has personal goals, some of which are in conflict with the team's overall mission to reach the summit.

The Everest simulation occurs over a sixty-minute period, with an hour afterward to discuss what happened. This intensive exercise uncovers a wide range of topics that teams face when presented with a challenging task, conflicting goals, and unex-

pected events along the way. It becomes clear at the end of the game that those teams that shared all the information they had, uncovered their common and conflicting interests, and communicated effectively were much more successful. It also reinforces the fact that teamwork is really hard, especially during stressful assignments. Despite the benefits of having more warm bodies to take on a task, it is challenging to get everyone aligned and literally moving in the right direction.

There are many effective tools for preparing individuals to work on creative teams. One of my favorites is the "Six Thinking Hats" model, developed by Edward de Bono, the renowned inventor of the concept of lateral thinking. This model describes six different roles we play on teams and shows the benefits of each role.[1] I introduce this model early in my creativity classes, because it gives the students a concrete tool that they can draw upon for the rest of the course—and the rest of their lives.

In de Bono's model there are six different roles we play on teams, each represented by a different colored hat. Most people have one dominant hat color, with one or two other colors close behind.

- A person who is drawn to the facts and is very logical wears the *white* hat.

- A person most comfortable generating new ideas wears the *green* hat.

- A person who uses intuition to make decisions wears the *red* hat.

- A person who is very organized and process-oriented wears the *blue* hat.

- A "devil's advocate," who uncovers what won't work, wears the *black* hat.

- A person eager to make everyone happy wears the *yellow* hat.

To demonstrate the value of this model, I ask my students to take a short "test" to determine their dominant working style. Even without the test, most people know what hat colors they typically wear. I ask the students to come to class wearing a shirt that matches their respective "hat" color so that they can easily see that they collectively represent the entire spectrum of working styles. I put them on teams of six, with others with different dominant working styles. Each student is given a real hat with six detachable tassels, one for each of the different colors. Over the two-hour class, the students attach one or the other of the tassels to the top of the hat to represent whatever role they are playing at that time.

The teams are given a challenging task to tackle, and each person gets a chance to try out playing different roles as they discuss possible solutions. We start with everyone wearing the same hat color, beginning with white, then green, then blue, and so on. Later in the session, the students are allowed to change hat colors at will, experimenting with those that feel most comfortable and those that feel awkward to them. They gain a shared vocabulary about the roles they play on teams, and realize that they can change those roles as easily as changing tassels on their hat.

The Six Hats model provides a useful vocabulary for group work of all types. For example, a team can explicitly state at the

beginning of a brainstorming session that they should all put on their green hats in order to generate ideas. This is particularly important for those who don't normally wear a green hat and are more comfortable evaluating ideas after they are generated. Later in the process, you can explicitly state that you are all going to put on your blue hats in order to plan for the next steps of the project. And during a risk-assessment session, everyone is invited to wear a black hat in order to see all the places where things might go wrong.

I wish I had been introduced to this tool early in my life, because I often fell into the common trap of thinking that everyone sees the world as I do. It was always surprising and often frustrating to work with others who approach problems from a very different point of view and with a very different process. I didn't understand their perspective and felt as though they didn't understand me. I almost always wear a green hat, with both blue and yellow close behind. As a result, I have had to learn how to work with others who naturally wear a black or a red hat, which are the least comfortable for me, and to don those hats when appropriate. In my work as a teacher and colleague, I also find this a valuable tool. By knowing which color hat each individual naturally "wears," I have a better understanding of why people act as they do and can respond accordingly.

I have been using the Six Hats model for many years and have seen over time that students and practitioners in different disciplines tend to wear characteristic hat colors. It might be that individuals are drawn to fields where their approach is most valued or that each discipline reinforces a specific working style. For example, the students studying electrical engineering tend to wear white hats and are, therefore, well tuned to manipulating lots of data. In the business school, a majority of students wear blue hats

and are very comfortable managing projects and processes. And in the drama and literature departments there is a preponderance of red hats, where students are comfortable drawing upon their feelings as they create new art. This is another reason it is fruitful to bring together people from diverse disciplines to generate ideas. They bring not only different knowledge, but also different approaches and working styles.

No matter how prepared you are, almost all teams face challenges at one time or another. At the Stanford d.school, we have a psychologist on staff whose job is to help with team dynamics in order to avoid common pitfalls and to help solve problems when they arise. Known as the d.shrink, Julian Gorodsky teaches classes on working in groups and coaches teams when they run into roadblocks as they tackle problems that have multiple possible solutions. Julian and his team develop and test team communication tools, such as a checklist for teams to fill out to help them evaluate and improve their working relationships. The diverse groups that use these tools find that they get along much better and that their creative output is much more robust. Here are a few sample questions on Julian's checklist:

- Do you take time out for reflection and evaluation of your team process?

- Do you stay together when the team is under pressure?

- Do you divide the workload relatively evenly?

- Do you take responsibility for problems instead of blaming others?

- Are you respectful of personal and professional differences?

There is a vast literature on team dynamics that compares the output of different types of teams. It is clear from this work that different types of teams are appropriate for different types of tasks. In a *New Yorker* article entitled "The Bakeoff," Malcolm Gladwell describes a fascinating experiment designed to see what types of teams are most creative.[2] He reviews how Steve Gundrum, a food scientist, put together three distinctly different teams who worked together for six months with the goal of coming up with a brand-new cookie that was both healthy and delicious. The first team was a partnership of two food experts. The second team was large and hierarchical, managed by one clear leader. The third team was composed of a large collection of experts, known in this experiment as the "dream team." This last team was based on the model of open-source software design, where large groups of experts build upon one another's ideas; hence there was great enthusiasm for what the dream team would create.

The winning cookie was created by the second team, managed by one clear leader. It turned out that although the dream team generated a wealth of ideas, there was so much dissension and conflict among the participants that the experience was stressful for all involved. It is interesting to consider how different the outcome would have been for the dream team if they had taken some time to talk about their creative process in advance, to think about the roles each played on the team, and to discuss when they should switch roles during the process.

This type of experiment, focusing on creative teams, can be done in a much shorter time period to uncover how groups

tackle a creative challenge. One well-documented approach is the "Marshmallow Challenge," in which teams are given eighteen minutes to build the tallest freestanding structure possible out of twenty sticks of spaghetti, one yard of string, one yard of masking tape, and one marshmallow. The marshmallow must be placed on the top of the finished structure.

Tom Wujec, an award-winning designer and innovator, has done this exercise with thousands of people around the world, from young kids to senior executives, and has seen that this simple exercise reveals consistent potholes into which teams fall when taking on a creative challenge that doesn't have one right answer. In only a few minutes it is clear that some types of teams are much more adept at coming up with ingenious solutions than others.

Recent business school graduates perform the worst on this challenge. As Wujec says, "They fight. They cheat. They produce lame structures." They spend so much time planning and jockeying to be the boss that the results are terrible. He found that seasoned CEOs do a pretty good job on this challenge. However, if an executive administrator is added to their team, they do much better. "It seems that the administrator's skills of facilitation make a big difference. . . . Encouraging timing, improving communication, and cross-pollinating ideas increase the team's performance significantly."[3]

Children do a terrific job on the Marshmallow Challenge. They have fun playing with the materials, experiment with lots of approaches, and prototype until they discover the solutions that work the best. In fact, play is an important variable for successful creative teams. Simply put, when you play, you are having fun. When you have fun, you feel better about yourself and your work. And when you feel better, you are much more creative

and deliver more. To quote Pixar's Brad Bird, who directed *The Incredibles* and *Ratatouille,* "The most significant impact on a movie's budget—but never in the budget—is employee morale. If you have low morale, for every dollar you spend, you get about twenty-five cents of value. If you have high morale, for every dollar you spend you get about three dollars of value. Companies should pay much more attention to morale."[4]

Marcial Losada has done extensive studies on the impact of positive and negative interactions on team dynamics. He has found that the optimum ratio for high-performance teams is five positive interactions for every negative interaction. This is known as the "Losada ratio." High-performance teams were found to have a positive-to-negative ratio above 5; medium-performance teams were found to have a ratio of about 2; and low-performance teams revealed a ratio well below 1.[5]

Play is one way to create positive interactions between those on a team. This doesn't mean that you spend your time doing frivolous things. Instead, it means that there should be a playful environment where experimentation and levity are encouraged. I am a fan of turning almost anything into a game in order to make the process fun. For example, I run a workshop designed to showcase the range of cultures in creative organizations. I could accomplish this by giving a lecture on the topic or by asking a group of executives to give a fifteen-minute talk on what makes their companies innovative. Instead, I use the hour to host a game show with several executives from a diverse range of innovative firms. The class is split into two teams. I ask the panel of visitors about the culture in their respective companies, including questions about hiring, team dynamics, and creativity tools. Either they can tell the truth or they can lie. That's when the fun begins. The student teams are contestants, deciding which

answer is true and which is false. The answers are always interesting and usually surprising. Everyone has a blast playing the game and learns much more in this playful environment than if they had listened to a lecture packed with facts on the same topic.

This approach is supported by recent neuroscience research, led by Mark Beeman at Northwestern University, that demonstrates that individuals are more likely to solve complex problems when they are in a positive mood, as measured by signature activity in the brain's cingulate cortex.[6] In one study, for example, college students who watched a short video of a comedy routine by Robin Williams were much more likely to solve a word-association puzzle, a proxy for creativity, than those who had watched a scary or boring video beforehand.

Since so much creative work is done in teams, it behooves us to prepare people to be effective team players. Unfortunately, this is rarely incorporated into our educational systems. I recently read an article about all the ways that kids cheat in school. I braced myself for a long list of terrible transgressions. About halfway through the list, I realized that almost all of the prohibited actions involved some form of collaborating with others! If we want increased creativity, it is time to encourage students to gain insights from everyone they can and to work in constructive teams where everyone contributes. This means changing the classroom experience and the way we measure success.

Schools should be preparing kids to be creative thinkers—not how to memorize facts that can be easily copied from others. When it comes to evaluation, we should consider giving problems without a "right" answer, providing challenges that require teamwork, and allowing students to use whatever materials

they can find to solve these problems. Students should come out of each exam with confidence that they can tackle other related challenges and shouldn't feel that it is "cheating" to tap into all the resources they can in order to find solutions to problems that come their way.

Those who are skilled at collaboration, including athletes and musicians who are required to work in teams, know how to lead, when to follow, and when and how to sacrifice their personal goals for the greater good. For most of us, this education comes quite late in life, when we are thrown into a situation where collaboration is required and we are totally unprepared. Many people never master these skills.

Teamwork is incredibly important when you are building organizations that foster innovation. You need a group composed of individuals who bring different perspectives to the table, who respect different working styles, and who resolve conflicts along the way. Great teams also have a healthy dose of playfulness and provide positive feedback. Habitats with effective teams are able to leverage all the other factors in the environment to enhance the group's creativity.

MOVE FAST— BREAK THINGS

Thomas Edison tried thousands of different materials for the glowing filament inside a lightbulb before finding one that worked. He famously said, "I have not failed. I've just found ten thousand ways that won't work." He knew that every failure reveals a truth about the world and that unexpected results are often the most interesting in that they uncover brand-new—and sometimes breakthrough—findings. Unexpected observations have led to a wealth of important discoveries, such as radio-activity, penicillin, and blackbody radiation in the universe. Max Planck, the famous physicist, said, "An experiment is a question which science poses to Nature, and a measurement is a recording of Nature's answer."

Creativity is like scientific research in that it involves doing things that haven't been done before. As such, creative endeavors are essentially experiments, and if they are really unique, you have no idea what will happen. The great news is that you already have vast experience with experimentation. Your entire life is one big experiment, from the moment of your conception, when two unique cells came together to create you, to today, where you get to design every moment of your day. From the time we are babies,

we do experiments to test how the world around us works. We naturally figure out what happens when we cry and what happens when we laugh. Learning how to walk and to talk requires a long series of trial-and-error experiments. As we get older, we do similar experiments, figuring out how to read and write, and when to talk and when to listen. Nobody has a script for life, and every day is filled with endless opportunities to try something new in order to see what happens. Each experiment—whether it works as expected or not—provides valuable input on the path to breakthrough ideas.

Experimentation is both a personal mind-set and a value in all organizations and communities. Individuals who want to increase their creativity need to be open to trying things they haven't done before, even when the results are completely uncertain. In addition, organizations that want to be more innovative need to be supportive of experimentation and to communicate that individuals won't be penalized for experiments that don't work out as expected. As a result, experimentation is relevant in the Innovation Engine in two places—attitude and culture. Each community should be designed to encourage experimentation, and each individual needs to feel free to experiment.

Unfortunately, our natural tendency to experiment is usually not supported or encouraged by traditional teaching techniques and work environments, where teachers lecture and managers tell their employees what to do. According to a recent study by Laura Schulz at MIT, giving people facts and specific directions rather than allowing them to discover information on their own not only inhibits their natural experimentation, but dulls their curiosity. Here is a short excerpt from an article by Jonah Lehrer about this research:

This research consisted of giving 4-year-olds a new toy outfitted with four tubes. What made the toy interesting is that each tube did something different. One tube, for instance, generated a squeaking sound, while another tube turned into a tiny mirror.

The first group of students was shown the toy by a scientist who declared that she'd just found it on the floor. Then, as she revealed the toy to the kids, she "accidentally" pulled one of the tubes and made it squeak. Her response was sheer surprise: "Huh! Did you see that? Let me try to do that again!" The second group, in contrast, got a very different presentation. Instead of feigning surprise, the scientist acted like a typical teacher. She told the students that she'd gotten a new toy and that she wanted to show them how it worked. Then, she deliberately made the toy squeak.

After the demonstration, both groups of children were given the toy to play with. Not surprisingly, all of the children pulled on the first tube and laughed at the squeak. But then something interesting happened: While the children from the second group quickly got bored with the toy, those in the first group kept on playing with it. Instead of being satisfied with the squeaks, they explored the other tubes and discovered all sorts of hidden surprises. According to the psychologists, the different reactions were caused by the act of instruction. When students are given explicit instructions, when they are told what they need to know, they become less likely to explore on their own. Curiosity is a fragile thing.[1]

It is important to keep in mind that we perform experiments every single day when we do things as simple as introducing ourselves to someone new or trying a new food. As a result, we get lots of opportunities to practice responding to unexpected results and learning from each one of them. Trained scientists know this well and, therefore, do their best to design experiments that answer an important question, no matter what the specific results. They know that each experiment offers valuable clues on the path to understanding. As the saying goes, "Genius is the ability to make the most mistakes in the shortest period of time." Each of those mistakes provides experimental data and an opportunity to learn something new. Like scientists, we need to stop looking at unexpected results as failures. By changing our vocabulary, by looking at "failures" as "data," we enhance everyone's willingness to experiment. This is a big idea!

Successful innovations result from trying lots of approaches to solving a particular problem and keeping what works. This necessarily results in a large number of unexpected outcomes and discarded ideas. If you aren't throwing away a large percentage of your ideas, then you aren't trying enough options. Consider the fact that only a tiny percentage of the roughly 200,000 patents that are issued each year in the United States lead to commercial success. According to Richard Maulsby of the U.S. Patent and Trademark Office, "There are around 1.5 million patents in effect and in force in this country, and of those maybe 3,000 are commercially viable."[2] However, this still means that there are 3,000 successful products. Without an environment that supports the development of those that didn't succeed, the viable innovations would likely

not see the light of day. The renowned entrepreneur and inves-
tor Vinod Khosla says that his firm, Khosla Ventures, invests in
projects that have a 90 percent chance of failure. The probability of
success for each venture is really low, but if the technology works,
it will literally change the world. He is willing to absorb the cost of
nine strikeouts in return for one grand slam.[3]

Every successful inventor and entrepreneur can tell stories
about surprising results and abandoned paths that led the way
to their best successes. Kevin Systrom and Mike Krieger started
their company, Burbn, with an iPhone app that lets you share
your location with your friends. The initial product wasn't as
successful as they had hoped, so they kept adding feature after
feature to see if any of them would increase the popularity of the
product. One of their many experiments included the ability to
take photos, edit them quickly, and post them instantly for others
to see. That feature was a huge hit. As a result, Kevin and Mike
decided to scrap the initial product altogether and focus entirely
on photo sharing, launching a new company called Instagram.

Instagram, which allows users to take photos with their cell
phones, do some quick and creative photo editing, and post the
photos for the world to see, saw membership grow from an initial
pilot set of one hundred users to one million users in only two
months. Now, twelve months later, it has twelve million regis-
tered users. Kevin and Mike are building on this platform to en-
hance functionality and to expand their reach around the world.

Kevin and Mike's success would never have happened if they
had not been willing to experiment and to learn from all the sur-
prising results along the way. Of course, they didn't want their early
experiments to fail. But those failures were an important part of
their learning process. Kevin admits that it was terribly difficult to

throw away the parts of the product that weren't attractive to customers, since they had worked so hard to develop them. However, they viewed each early trial as fertilizer for the next experiment.

This doesn't just happen in high-technology ventures. In fact, it is an approach that serves everyone well and feeds the creative process. A terrific example from the arts comes from authors Dave Barry and Ridley Pearson, who wrote *Peter and the Starcatchers*, which tells the story of how the imaginary character Peter Pan became the boy who would not grow up. The book was turned into a musical-theater production that became a hit in New York. As they were crafting the show, they ran a monthlong experiment in which they changed the script and staging every night. Each iteration was a low-resolution production, without fancy costumes, backdrops, or props, which allowed them to experiment very quickly with different approaches until the best one finally emerged.[4]

Writing this book, in fact, required the same approach. For every three paragraphs I wrote, I'm sure that I deleted two, as I constantly tested new ideas and approaches. The cutting-room floor is littered with stories that didn't fit and ideas that didn't fly. I crafted the Innovation Engine dozens of ways before finding one that clicked. And I sent seven different versions of the first two pages of the book to my editor in the hope of finding one that worked. Yes, it was hard to eliminate the words I spent so much time writing and to start over again and again. However, I knew that this editorial process makes the end result much better and is the key to any craft. As the esteemed writer William Faulkner famously said, "In writing, you must kill your darlings."

This should sound familiar. It is similar to Darwin's description of evolution, in which nature performs a vast number of

experiments and keeps what works. Animals and plants come into existence all the time with various mutations. Each mutation is nature's experiment. If it is beneficial, the result is repeated in future generations. If it isn't, then the failed experiment was just that. All you have to do is look around you to see all the amazing plants and animals that are the result of nature's experiments.

A few schools have adopted an approach that allows students to learn through experimentation. An example is the Tinkering School, run by Gever Tully. It offers a program where kids ages eight to seventeen learn how to build things by "fooling around." All of the activities are hands-on, and the kids are invited to come up with "wild ideas, crazy notions, and intuitive leaps of imagination." They learn how to figure things out by experimenting; they realize that most things don't turn out as expected and that failures can be analyzed to determine what they should do differently the next time around.[5]

This approach is not limited to young children. At Olin College all classes are taught through experimentation. This new engineering school uses experiential learning for all subjects. Instead of lectures, the students go to the lab to discover the material on their own and build inventions that use the principles they are learning. For example, on a recent visit to Olin College, I saw the students designing and building noninvasive monitors to measure oxygen saturation in the blood. The devices they were building, without instructions, are similar to the oximeters that are used in operating rooms around the world. Not only is this much more stimulating than a traditional lab assignment, in which students essentially follow recipes, but the students gain

the confidence that they can come up with their own experiments, learn from the inevitable failures, and design creative solutions to problems they face in the future.

Master inventors appreciate unexpected outcomes. Mir Imran, whose stories of successful medical inventions were described earlier, says, "Failure is a constant companion, and success is an occasional visitor." Mir appreciates failures, because each one teaches him something important on the road to a breakthrough idea. He believes it is up to each of us to mine our failures for valuable information and insights. Failure and success are closely intertwined, and for him every failure follows a series of successes, and every success follows a series of failures.[6] The key is seeing the process of trial and error on the way to a success as a series of experiments. If you look at your failures in this light, they take on brand-new meaning. This is true in all of life's ventures and adventures, large and small.

Since experimentation inevitably results in unexpected findings, experimentation can be considered risky. In order to give people a chance to experiment with risk taking and failure, my colleague Leticia Britos and I created a workshop called the "Failure Faire." The room is set up like a carnival, balloons and all, with booths that participants can visit. One booth is focused on intellectual risks, another on financial risks, a third on emotional risks, and a fourth on physical risks. We also give participants a "risk-o-meter," which they use to measure their comfort level when taking these different types of risks. The goal is for each participant to get a chance to think about different types of risk taking and to reflect upon what it feels like to fail.

At the intellectual-risk booth participants are given lateral-

thinking puzzles to solve. They can work on them either as individuals or in teams. These puzzles have nonobvious solutions that require moving beyond traditional calculations. The participants are challenged to push through their natural tendency to look up the answers and to find the solutions on their own. Sample questions are below, and the answers can be found in the notes. How long will you spend attempting to solve these puzzles?

1. What can be seen in the middle of March and April that cannot be seen at the beginning or end of either month?

2. Two men are lost in the woods. One starts walking north, and one starts walking south. In a quarter of an hour the two men bump into each other. How did that happen?

3. Two sisters have newborn babies who are exactly one hour old. One was born at night and one was born in the morning. How can this be?

4. There are six eggs in the basket. Six people each take one of the eggs. How can it be that one egg is left in the basket?[7]

At the financial-risk booth the participants play a special gambling game, designed by Leticia, that forces them to take ever increasing risks of losing the five dollars they each brought to the workshop. Each round of play increases the reward, but also decreases the probability of winning. Some people are willing to risk all their money for a small chance of making a big winning, while others play it much safer, opting for a higher probability of winning a smaller amount.

At the physical-risk booth everyone is encouraged to juggle balls and perform other physical feats and to evaluate how they felt before, during, and afterward. It would have been more telling if we had asked them to jump out of airplanes with parachutes or to ski down steep slopes, but we weren't willing to take the risk that someone would really get hurt.

Finally, at the emotional-risk booth they had to create a postcard with a secret. This was inspired by the PostSecret website, which anonymously shares secrets on postcards that people around the world send in.[8] Almost everyone participates, despite the sensitivity of this exercise. With only fifteen minutes, participants produce postcards with remarkably personal secrets about their insecurities, their fantasies, and their limitations. We follow this activity with an in-depth discussion about risk-taking, experimentation, and failure. The students realize that even in the low-risk, classroom environment, some risks were easier to take on than others, and that they each have a unique risk profile.

So how do you create a habitat that fosters risk taking and experimentation? The best ways involve encouraging experimentation and evaluation of the results. The key is to get concepts out in front of others as soon as possible, so that everyone receives rapid feedback on their ideas. The longer you work on an idea, the more attached to it you become. Therefore you need to be encouraged to show your work to others when it is still raw, and to get their comments, before your ideas are hard to release if they aren't working. Unfortunately, in most work environments people are strongly encouraged to polish their work before it sees the light of day. The more time they spend polishing, the more

wedded they get to the ideas, and the less likely they are to release them if they aren't working.

A great example of a company that does this well is 1185 Design in Palo Alto, led by Peggy Burke. They create branding materials, such as logos and websites, for all types of businesses. Its clients include well-known firms such as Adobe, Cisco, SAP, Symantec, and Zynga. A dozen designers listen to a formal presentation for each company, and then they each go off to generate dozens of ideas for the company logo in only a few days. They all come back together and show their raw concepts to the entire group. After getting feedback, they throw most of the ideas out, and then go back to work on those that survived the cut. The key is that each designer comes up with a wealth of different solutions that can be tested rather than polishing one single idea. Soon they are ready to show a large set of logos to their client, who gives feedback and suggestions. Again, the surviving designs go back to the drawing board for more refinement. This process of trial and error leads to terrifically diverse and interesting options, the best of which survives to the end.

Another inspiring example comes from Elise Bauer, who launched and writes the Simply Recipes blog. With millions of visitors each month, the site is one of the top cooking websites in the world. But it certainly didn't start that way. I have known Elise for many years and watched with great sadness when she got very ill with chronic fatigue syndrome. She was so weak and tired that most days she could barely get out of bed. The only thing she had the energy to do was write. It was 2003, and blogs were in their infancy. She decided to try her hand at writing a blog. But she didn't write one blog; she wrote five different blogs to see which topic resonated with readers and which she enjoyed

the most. She had one on music, one with book reviews, one on marketing, one with random thoughts and reflections, and one with recipes for her family.

Soon after she started, she learned several fascinating things about these blogs. First, she realized that she found it challenging to capture the essence of the music in words. Second, it was terribly time consuming to read books and write reviews. And, finally, she saw that her recipe blog, despite the fact that it wasn't intended for the public, was getting more and more traffic. In fact, some of her recipes were coming up as the number one search result on Google. With this feedback in hand, Elise dumped all the other blogs and focused on food.

Elise did not stop there. She continued experimenting, always watching the users' responses to the types of recipes she posted, the kinds of photos that were included, the level of detail in each recipe, and how the navigation and ads were placed on her site. Even now, her readers continue to provide fabulous feedback in their direct comments and their behavior. She quickly learns if certain recipes aren't working for readers and updates them with tips; if they are really problematic, she removes them. There are surprises every day. For example, she posted a simple, old-fashioned recipe for cinnamon toast that was unexpectedly popular. She quickly learned that readers love to see nostalgic recipes that bring back childhood memories. Elise reads and responds to almost all of the comments on the blog, embracing both the positive and the negative reviews, knowing that all the feedback continues to make the site stronger.

You can practice performing small experiments every day, until doing so becomes quite natural. These experiments need not be earth-shattering, just interesting. When I was a girl, my

father turned almost everything we did into an experiment. When we went out to dinner, for example, he would blindfold all three kids and feed us black and green olives to see if we could tell the difference. He would keep a tally and give us the results at the end. Or, when one of us left the cap off the toothpaste tube, he would line us up, ask us questions, and take our pulses, similar to a lie detector test. He would start with easy questions such as "What is your name?" or "What is your birthday?" while he took our pulse. Then he would ask the key question, "Did you leave the cap off the toothpaste tube?" He would see if our pulses increased while we answered this question as an indication that we might not be telling the truth. This was a playful way to add experimentation to our everyday lives. Soon it became a natural way to approach the world.

Experimentation should be coupled with the ability to turn on a dime when it is clear that your current strategy isn't working. Eric Ries popularized this method in his work on "lean start-ups." A great example of this approach is Chegg, which rents textbooks to college students. Chegg started out with the goal of creating an online bulletin board for the university crowd. When they released the product, however, there was no traction at all. It was sputtering along without much enthusiasm from its users.

The founders of Chegg looked at the data and noticed that one part of the site was showing promise: students were selling a large number of used textbooks to one another. Bingo! They decided to pivot—to change the direction of the entire company. Their new idea was to rent textbooks to students for the quarter or semester they needed them. They did a quick experiment by

launching a new site, called Textbook Flix, to see if students had any interest in renting textbooks. The site was completely raw, and they had no inventory of books. When orders came in, they literally bought books on Amazon and had them shipped directly to the customers. Their goal was to test the demand for the product. It worked! There was clearly a big demand for rented textbooks. They quickly turned Chegg into an online textbook rental firm, and it has become a fast-growing e-commerce businesses. This would never have happened if they hadn't been willing to do some quick experiments, to release a minimum set of features to test their hypothesis, and to pivot when it was clear that their original plan wasn't working.

This process gets baked into fast-moving, innovative companies such as Facebook. According to Randi Zuckerberg, former head of marketing for the company, the internal company motto is "Move Fast—Break Things." Company leaders emphasize speed over perfection as they encourage everyone to try new things. They know that on average about one-third of all the projects they attempt will work out. That means that in order to get four successes, they need to do a dozen experiments.

This process is formalized in Facebook's monthly twelve-hour "hack-a-thons," during which everyone is invited to stay up all night, from 8:00 P.M. to 8:00 A.M., and work on a new project. The key is that the projects have to be completely unrelated to each person's day job. They are true experiments. The next day, each person or team gives a five-minute presentation on what they accomplished. Each month hundreds of people participate, and there are dozens of presentations. The projects can be anything, from painting a mural on the walls to coding a new application. Some of these experiments are so interesting that they become full-time projects for the hackers. Facebook Chat is an

example of a hack-a-thon project that turned into a full-time job.

In addition, some hack-a-thon experiments that seem pretty pointless on the surface uncover interesting opportunities. For example, two engineers decided to participate in the hack-a-thon, but had no idea what they wanted to do at the beginning of the night. After some playful brainstorming, they decided to rig up a keg of beer with a card reader. When you swipe your ID card, you get a beer and the reader takes your photo. The photo is posted to Facebook with a status update, saying that you just had a beer. Although it sounded pretty frivolous when these engineers presented the idea the next day, others quickly realized that this technology could be used elsewhere. Now the same approach has been implemented at conferences, so that attendees can swipe their ID cards at various stations, and it automatically updates their Facebook page.

This same type of energy is found at Startup Weekend, which provides would-be entrepreneurs with the opportunity to meet and start a new venture over an intense fifty-four-hour period. These weekends are essentially laboratories where teams get together and experiment with a novel idea. They begin on Friday night with pitches from those who have an idea for a new venture. Teams organically gather around the projects that interest them and they get to work. Many of the participants are technically oriented, while others contribute business skills. Together they start building rapid prototypes and engaging with potential customers to demonstrate the validity of the concept. On Sunday night each team shows what they have accomplished and gets feedback from judges. This approach has caught on, and the organization now offers dozens of Startup Weekends around the world each year.[9]

· · ·

Many established firms work hard to find ways to build a culture that supports experimentation, while keeping the trains of their core business running on time. For example, Google has a 70-20-10 rule. It puts 70 percent of its resources into the core business, 20 percent into experiments that are related to the core business, and 10 percent toward wild new ideas that will play out over a long time horizon and have a high risk of failing. An example of a high-risk experiment at Google is the development of a driverless car. The system uses information gathered from Google's Street View software along with artificial-intelligence software, video cameras, and sensors on the vehicle. The project is not only technically complicated, but would require brand-new laws that would allow driverless cars to share the roads.[10] It will be years before Google knows if this project will succeed. But it is willing to use a small percentage of its resources on this high-risk project. If it works, the benefits will be enormous. In addition, there are likely to be many fascinating, yet unexpected, discoveries along the way.

All of these examples reinforce the fact that experiments provide essential information—whether they work out as you had hoped or not. In fact, failed experiments are incredibly valuable in that they help close off paths that aren't viable. Of course, nobody wants to fail, nor should they. But failure is an inevitable part of the creative process when you are doing things that haven't been done before. As Henry Ford is claimed to have said, "Failure is only the opportunity to begin again more intelligently." A robust Innovation Engine, therefore, necessitates individual attitudes and a collective culture that fosters experimentation.

IF ANYTHING CAN GO WRONG, FIX IT!

Owing to increased enthusiasm about creativity and innovation, there were many more applicants for our creativity course than spots available. Therefore, the teaching team had to whittle the class down from 150 to 40. The application process involved an in-class activity and designing the book jacket for one's future autobiography. Following our decisions last year, I received a note from a student who hadn't been admitted asking for an explanation. I sent him a polite note in response about the challenges of picking students when all the applicants are qualified. He wrote back again with an unusual request. He said that he *never* gets into the courses he wants. He begged me for more specific feedback, saying that he is a hardworking student who was admitted to the school on an academic scholarship.

I felt his frustration and wanted to help out. I thought carefully about how to respond and sent him the following message: "If there is a course that you really want to take and you don't get a spot in the class, then just keep showing up. Spots usually open up during the first week as students drop the class for a variety of reasons. If you're there, you are almost guaranteed the spot."

He wrote back, "Thank you for this advice. I assume that won't work for your class."

I stared at his e-mail for several minutes and then responded, "Yes, you're right. It won't work."

I had handed him the ruby slippers and he didn't take them. This is in sharp contrast to another student who wrote to me the same day. She didn't get into the class either, but her approach was completely different. She said, "Thank you so much for the first class. I really enjoyed it and learned a tremendous amount. Would it be possible for me to attend just one more class? I know it will be incredibly valuable."

I agreed to let her come to the next class, and as predicted, someone dropped the course and she was admitted.

These two students are both intelligent. The difference between them is their attitude. The first fellow was convinced that he wouldn't get into the class and didn't even see the possibility when I placed it in front of him. The second student created a way to get what she wanted. In fact, *believing* that there is a solution to your problem is a critical step in finding one. So many people give up long before they find the solutions to their challenges— big and small—even when they are in plain sight, because they don't have the conviction that the problems can be solved. Essentially, if you believe something is impossible, then it is.

I saw this situation over and over again at the end of 2010 when I visited Japan for the first time. Almost every person I met said something like: "We are trapped in the midst of a twenty-year-long economic depression in Japan." After hearing this dozens of times, I realized that this message is ingrained in everyone's minds. Young people in their early twenties have been hearing this for their entire lives. This mantra, which is repeated daily in the media, in schools, and at home, is terribly discourag-

ing. With this attitude, it becomes nearly impossible to see opportunities right in front of you.

One way to change your attitude is to change your vocabulary. At Facebook, Randi Zuckerberg told her team that she was changing the name of their group from Consumer Marketing to Creative Marketing. Despite the fact that it seemed like a small change, it had an instant impact on the group. Immediately, they redefined themselves as a creative hub of the company, even though nobody else in the firm knew about the name change. Within a few days the team reorganized the space, bringing in new furniture and art supplies and designing a media wall to showcase their creative accomplishments. They started coming up with more innovative ideas and suggested new projects that reflected their newly defined role in the company. It became abundantly clear that Randi's team was incredibly creative, but that they hadn't thought that it was their primary role to generate new ideas. The change in their name gave them explicit permission to exercise their imagination.

This story is a reminder that you see what you want to see. If you view yourself as a creative person, you are much more likely to come up with innovative ideas. But if you define yourself as a worker bee who merely implements the ideas of others, then that is the role you will play. Of course, creative output takes more than just changing the name of your organization. But in this case, a change in name served as an important catalyst for unlocking the group's innate ability to innovate.

Heidi Neck, who teaches entrepreneurship at Babson College, runs a workshop in which she asks the students to complete a jigsaw puzzle. When they are done, they go into another room to create a patchwork quilt, starting with a crazy collection of different fabrics. When they're finished, she compares the two approaches and end products. Putting puzzles together requires a

fixed goal, and if a single piece of the puzzle is missing, you aren't able to succeed. On the other hand, making a quilt is an open-ended process in which you can quickly change direction based upon the pieces you have on hand. And no matter what materials you are given, you are able to complete the quilt. Heidi shows her students that innovators and entrepreneurs are much more like quilt makers than puzzle builders. They have a mind-set that allows them to respond to the unexpected and to leverage the resources that are available in order to create something of value rather than waiting for all the expected pieces to show up.

There are many people who are blinded by the challenges they face, believing that they don't have all the pieces they need to complete their "puzzle." They are unable to see the endless opportunities in their midst. There are many examples of this in Chile, where people rarely leave the central city of Santiago and don't fully appreciate all the remarkable assets in their country. However, the government of Chile and the universities are trying very hard to change the culture and to encourage young people to take on entrepreneurial endeavors that take advantage of the resources in the region.

A new, bold experiment called Start-Up Chile is designed to jump-start this process.[1] The Chilean government is literally importing early-stage entrepreneurs from around the world who are starting new ventures with the goal of infecting the local community with an entrepreneurial spirit. Start-Up Chile offers start-up companies the chance to come to Chile for six months to start their company. Each venture that is selected to participate is given $40,000 to pay for their local expenses as well as space in the Start-Up Chile collaborative workspace. The participants share what they are doing and are encouraged to hire local talent to help with their venture. The goal is to inspire people in Chile

to consider starting their own companies by exposing them to role models from around the world. Start-Up Chile literally wants to change their minds, making them less fearful of failure and more open to opportunities.

A study by Baba Shiv, a professor at Stanford Graduate School of Business, suggests that there are two distinct mind-sets related to taking on challenges. Some people are driven by their strong fear of failure and therefore are unwilling to take on challenges that have a chance of not turning out well. Others are driven by their strong fear of missing an opportunity. The latter group is willing to take on projects that might not turn out as expected, because they don't want to miss the chance that it will succeed.[2]

I have also seen a hybrid group who battle with both a deep-seated fear of failure and a powerful fear of missing out. They struggle intensely, wanting to do something daring and important, but are terribly afraid to fail. They desperately want to shed their fears, so that they can take on the challenges they see in front of them. The best way to overcome this angst is to start by taking small chances first, to build your creative confidence. The more confidence you have, the better able you are to push through your fears to take on larger and larger challenges. Eventually, your drive to succeed outweighs your failure.

There are inspiring examples of people who are so driven to succeed that they are literally willing to knock down any barrier to reach their goals. John Adler, a prominent neurosurgeon at Stanford, was exposed in the mid-1980s to a fascinating new way to perform minimally invasive brain surgery while he was doing a neurosurgical fellowship at the Karolinska Institute in Sweden. Essentially, a metal frame was put on a patient's head to hold it

firmly in place, and then radiation—a gamma knife—was used to ablate, or remove, the tumor by attacking it from a wide range of angles. The radiation was well below the amount that would damage normal brain tissue. However, the radiation would be cumulative at the site of the tumor and kill those cells selectively.

John realized that this approach could be used with all types of solid tumors if the frame was taken out of the process. With great enthusiasm he set out to design a new approach. He envisioned creating a "cyberknife" that used computers to compare real-time digital X-rays of a patient's body with their prior CT scans, so that a surgeon could accurately irradiate a tumor from all different directions without using a frame to hold the patient in a specific position.

This technology took eighteen long years to bring to commercial success. Over that time John was faced with challenge after challenge, and he said, "If it weren't for bad luck, I wouldn't have any luck at all." There were huge problems raising money to fund the development of the product; he had limited knowledge of how to navigate in the world of business; the early products performed poorly; and even his closest colleagues called this "Adler's Folly."

Despite the obstacles, John forced himself to stay positive and kept putting one foot in front of the other. He put all of his energy into making this a success, including taking a leave of absence from his job at Stanford to take the reigns as CEO of his business in 1999. He passionately worked with potential customers and investors to articulate the vision for the business. He would do anything to close a deal, even meeting with one customer more than thirty times. Eventually, after nearly two decades of tireless work, this technology is now available to treat tumors that would have required invasive surgery. This would never have happened

without John's unrelenting belief in the mission and his willing-
ness to walk through walls to make it happen.[3]

You can master the ability to do this, too. Lonny Grafman,
who teaches engineering at Humboldt State University and is the
founder of Appropedia, provides his students lots of opportuni-
ties to learn these skills. Lonny gave his students the following
problem to solve: turn the massive amounts of plastic waste on
the beaches of Haiti into plastic molds used for making nut shell-
ers. It turns out that fiberglass molds were being shipped from
the United States to Haiti, so that Haitians could make concrete
nut shellers, the use of which increases production, raises in-
comes, and prevents the early arthritis caused by hand shelling. It
would be much more cost effective to make the fiberglass molds
locally in Haiti, especially if this could be done using the plastic
bags found in vast quantities on the beaches and in landfills.

After a few weeks working on the project, the students came
to Lonny and told him it couldn't be done. Melting the plastic to
make molds released toxic gases that were unacceptable. They
were ready to give up on the project, claiming defeat. Lonny told
them that there are *always* solutions. He gave them an impas-
sioned pep talk and encouraged them to go back to the drawing
board and think again. There had to be a way to make this work,
maybe not in the way they predicted, and maybe not perfectly,
but there was a way, he told them.

Just one day later, the students came back with a solution. In-
stead of melting the plastic bags, they sliced them into thin rings
and then wove them together into a plastic fabric. This fabric was
then heated slightly, using an iron, so that it solidified into the
right shape. The temperature was much lower than the melting
temperature, which produced the toxic fumes. The students not

only were successful, but learned that if you know there is a solution, you are much more likely to keep looking until you find it. As Henry Ford famously said, "Whether you think you can or you can't, you're right."

Peter H. Diamandis, founder of the X PRIZE Foundation, is a master of this mind-set and uses it when approaching terrific challenges that face our planet. He identifies the biggest problems in the world, the ones that seem impossible, and then invites others to come together to solve them. Peter provides large incentives by offering impressive prizes to those who succeed.

Grand challenges and large prizes have motivated many great accomplishments. For example, the 1919 Orteig Prize paid $25,000 to the first person to fly nonstop between New York and Paris. This competition stimulated a vast number of experiments and eventually led to Charles Lindbergh's famous flight in 1927. Even more remarkable, the United States put a man on the moon in less than nine years after President John F. Kennedy set forth that challenge in 1961. The prize in this case was global recognition, motivated by intense international competition. Everything that was needed to take on that audacious goal had to be invented in order to succeed. And it was all done by a team of engineers with an average age of twenty-seven, with less computing power than a modern cell phone. In addition, according to author Catherine Thimmesh, approximately four hundred thousand people were directly involved in accomplishing this amazing feat, including seventeen thousand workers at Kennedy Space Center, seventy-five hundred Grumman employees who built the lunar module, and five hundred designers and seamstresses who constructed the space suits.[4]

Peter uses a similar approach at the X PRIZE Foundation, which is a nonprofit organization with the mission to inspire

radical breakthroughs that have a huge positive impact. Seventy-seven years after Lindbergh's flight, the first X PRIZE paid $10 million to a team led by Burt Rutan for developing a private spaceship. Their challenge was to create a spaceship that could be used repeatedly for civilians who want a chance to experience space travel. It was to carry three people—the equivalent of a pilot and two passengers—up to an altitude of 100 kilometers and to repeat the flight twice in two weeks. This challenge inspired twenty-six teams to take part, resulting in a huge investment of their time, energy, and creativity.

To follow this great success, the X PRIZE Foundation created new challenges and prizes with the goal of inspiring further innovation around massively complicated problems. One prize, the Archon Genomics X PRIZE, rewards $10 million to the first team to sequence a hundred human genomes in ten days. Another prize, the Google Lunar X PRIZE, offers $30 million to the first privately funded team that lands a robot on the moon that travels 500 meters over the lunar surface and sends back photos. And another prize, the $10 million Progressive Automotive X PRIZE, was awarded to a team that built a car that gets over 100 miles per gallon gasoline equivalent (MPGe) under normal driving conditions. Future prizes are envisioned to solve problems related to energy and the environment, education and global development, health and life sciences, and of course space exploration.

Peter sees the world as full of opportunities, and no problem is too large for him to tackle. He once saw a sign with Murphy's Law in a colleague's office. It said, "If anything can go wrong, it will." Peter interpreted that common saying as an admission of defeat. He walked over, crossed out "it will," and wrote, "FIX IT!" in large letters. The new sign said, "If anything can go wrong, fix it!" We should call this revised rule "Diamandis's Law."

Peter Diamandis launched Singularity University in order to teach others to adopt the same philosophy and skills. Participants come from all over the world to learn how to solve huge problems. They are taught how to generate breakthrough ideas and are challenged to use these skills over the course of a few months to come up with products and services that will positively affect a billion people in ten years. For example, one team took on the challenge of reducing the number of cars in the world. They envisioned turning every car into a shared vehicle. Instead of letting cars sit idle all day long, individuals would get paid to let others drive their car, maximizing utilization of each vehicle and, therefore, reducing the number of cars that need to be built.

Another team set out to capture the precious metals from used electronic equipment, which produce terribly toxic waste. They are developing a single-cell organism that extracts the metals from the discarded material, so that the metal can be reused. And another team is working on the wild idea of building massive structures in space using 3-D printing in zero gravity. This project would dramatically change space exploration by making the process of building space stations or spaceships much less expensive. All needed parts would literally be built on the fly. Each of these projects is a daunting task, but with perseverance and an attitude that it can be accomplished the teams are making remarkable progress.

Thinking even further into the future, the National Aeronautics and Space Administration (NASA) and the Defense Advanced Research Projects Agency (DARPA) are working on ways to travel to another star in our galaxy! A recent conference brought together all those working on the 100-Year Starship. Participants included experts in physics, mathematics, engineer-

ing, biology, economics, and psychological, social, political, and cultural sciences. The agencies' goal is to inspire breakthrough innovations that will enable interstellar space travel while generating inventions along the way that will benefit humankind. They acknowledge that challenges such as these are designed to push the boundaries of our imagination.

Tapping into powerful emotions is yet another way to increase drive and motivation. Many artists and entrepreneurs are propelled forward in their pursuits not by their intellectual curiosity, but by strong feelings, including anger, sadness, joy, or frustration. Many of the best poems are written in times of dire depression, some of the most engaging prose is crafted to convey a heartfelt message, and some of the most successful companies are launched to right a wrong. Creativity isn't entirely a cerebral act, but rather is augmented by strong emotions that fuel fresh ideas.

A wonderful example comes from Chicago where Brenda Palms Barber started a business to employ former prison inmates. She ran a not-for-profit company that was dedicated to helping former felons get jobs. This was a challenging proposition since few employers were willing to hire these people. Her innovative solution was to start her own company to employ the former inmates. The new company, Sweet Beginnings, makes honey and honey-based skin products. The employees raise bees, manufacture the honey, manage the company website, and work in sales and customer service. With these jobs on their résumé, 85 percent are able to find other jobs after working there. This business, fueled by a passion to help those who are starting over, is considering expanding to other cities across the country.[5]

This story is a sweet reminder that in order to find creative solutions to big challenges, you must first believe that you'll find them. With this attitude, you see opportunities where others see obstacles, and are able to leverage the resources you have to reach your goals. Your beliefs are shaped by the language you use, and the language you use is shaped by your beliefs. This concept is both profound and freeing. Your Innovation Engine is limited only by your dreams and drive, which together open up a world of possibilities.

ELEVEN

INSIDE OUT AND OUTSIDE IN

Sangduen Chailert, known as Lek, has always loved elephants. She grew up in the small rural village of Baan Lao in a remote part of northern Thailand and became passionate about elephants as a youngster when her family cared for one. As she grew older she saw how terribly most elephants in captivity are treated, and saving elephants became her mission in life. Her passion led her to learn as much as she could about these endangered animals. She found that the elephant habitats in Thailand are shrinking quickly and that as few as five hundred wild elephants remain in the country. In addition, most of the two thousand domestic elephants that entertain tourists have a grim future. Lek decided that she had to do something meaningful to protect them.

In the early 1990s, Lek founded the Elephant Nature Park near Chiang Mai, Thailand. She struggled desperately to raise the funds needed to take care of the elephants and to fight against fierce local critics who tried to prevent her from doing this work. Despite these obstacles, Lek came up with an innovative way to rescue and protect elephants that have been injured by land mines and excessive work in the logging industry and that have

been mistreated as circus entertainers. The Elephant Nature Park is now home to thirty-five elephants and is open to visitors and volunteers who are transformed by their experience with these amazing animals.

Essentially, Lek's *attitude* about elephants motivated her to gain *knowledge* about these magnificent animals—a rich *resource* in Thailand. Her knowledge became a toolbox for her *imagination*, which she drew upon to create a *habitat* where she could protect the animals and share her passion and knowledge with others. The visitors' new knowledge and appreciation changes their *attitudes* about elephants and is slowly changing the *cultural* response to these creatures. This is an example of the Innovation Engine at work![1] The Innovation Engine captures the relationship between the factors that influence your creativity, both *inside* your mind and in the *outside* world.

On the inside, your creativity is influenced by your knowledge, imagination, and attitude. These factors are inspired by Benjamin Bloom's original work in the 1950s on learning. He focused on what you *know*, what you *do*, and how you *feel*, which are generally known as knowledge, skills, and attitude. Since we're focused specifically on creativity, I've changed "skills" to "imagination," as imagination captures the specific skills needed for creativity. Let's look at the three factors on the inside of the Innovation Engine in more detail.

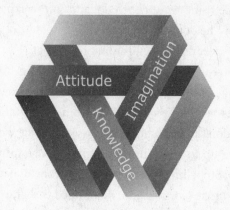

KNOWLEDGE

Knowledge in any domain, from minerals to music to mushrooms to math, is the fuel for your imagination. That is, the more you know about a particular topic, the more raw materials you have to work with. For example, if you want to design an inventive solar car or find a cure for cancer, you need to begin with a base of knowledge about engineering or biology, respectively.

Some people argue the contrary—that there is a benefit to having a "beginner's mind," so that you come at challenges without established knowledge or entrenched beliefs. There are examples that bear this out. However, if you look closely, you will see that in most of these cases these folks have expertise in a related or tangential field upon which they can draw. Successful entrepreneurs often come from outside the domain of their new venture, and their unorthodox ideas aren't inhibited by industry doctrine. They dominate the field, because they don't know what can't be done. As Mark Twain famously said, "The best swordsman in the world doesn't need to fear the second best swordsman in the world; no, the person for him to be afraid of is some ignorant antagonist who has never had a sword in his hand before; he

doesn't do the thing he ought to do, and so the expert isn't prepared for him; he does the thing he ought not to do; and often it catches the expert out and ends him on the spot."[2]

Serial entrepreneurs, who start companies in diverse fields, are masters at building on their accumulated knowledge from past ventures as they move fluidly from one endeavor to another. They don't initially have expertise in the new domain, but quickly come up to speed using past knowledge to propel them forward. A compelling example comes from a new company called the Climate Corporation, mentioned earlier, which makes sophisticated software that enables it to offer weather insurance to farmers. In this fast-growing firm, not a single person in the company, including David Friedberg, the founder, has any formal training in meteorology or agriculture. David was trained as an astrophysicist, spent time as an investment banker, and worked on strategy at Google. Other members of the company also bring a deep knowledge in diverse fields, each of which sheds a fresh light on the problems they are trying to solve. Team members include mathematicians, engineers, and even a neuroscientist. The neuroscientist, for example, was trained to analyze complicated, quickly changing data and is using that knowledge to analyze weather patterns. Over time they are each building an expertise in agriculture and meteorology, which they will bring to their subsequent endeavors.

IMAGINATION

Your imagination—the ability to create something new—is a powerful force. It is the catalyst required for creative combustion. Without it, new ideas are impossible to generate. There are specific skills and approaches you can hone to unleash your

imagination. These include connecting and combining ideas, reframing problems, and challenging assumptions. These tools, addressed in detail in earlier chapters, allow you to use what you know to generate fresh ideas.

Karl Szpunar and Kathleen McDermott have examined the literature on how our imagination is deeply connected to memory.[3] They cite a wide range of psychology and neuroscience research that reinforces the hypothesis that the same parts of our brain are invoked when we remember and when we imagine, including evidence that those who don't have the ability to remember the past are unable to conjure up a vision of the future. Our imagination essentially transforms what we know—our memories—into new ideas. For example, we remember a car and a bird, and our imagination connects those concepts into new ideas, including a flying car and a mechanical bird.

Using your knowledge about the world as fuel, your imagination is an endless renewable resource. To demonstrate this point, I ask students in my classes to do a warm-up exercise inspired by Patricia Ryan Madson in her book, *Improv Wisdom*.[4] I tell them there is an imaginary present sitting on their desk and ask them to pick it up and feel how heavy it is, how big it is, and to imagine how beautifully it is wrapped. Without opening it, they are to imagine what's in the box. Once they have that in mind, they are to open the box slowly to see what is inside. I tell them that they will be surprised to find that the present *isn't* what they expected. We go around the room and each person says what they thought was in the box and what they actually found. Everyone names different things, from books and chocolate to airplane tickets for an around-the-world adventure. I then ask them to look into the box to find yet another present, and another, and another. Each time they bring out something new and surprising. The key is

that this "box"—your imagination—is bottomless. If you dig down, you will always find something new.

ATTITUDE

Your attitude is the spark that jump-starts your creativity, and without the attitude that you can come up with breakthrough ideas, your Innovation Engine comes to a standstill. Your attitude, or mind-set, determines how you interpret and respond to situations, and it has deep neurological underpinnings.

A new study, to be published in *Psychological Science,* found that those people who believe they can learn from their errors have different activity in their brains in response to mistakes than people who think intelligence is fixed. Jason Moser and his colleagues at Michigan State found that those individuals who think intelligence is malleable say things such as "When the going gets tough, I put in more effort" or "If I make a mistake, I try to learn and figure it out." However, those who think that their intelligence is fixed don't take opportunities to learn from their mistakes.[5]

While measuring their subjects' brain activity (EEG), Moser and his colleagues gave them a simple task that is easy to mess up. Subjects were asked to identify the middle letter of a five-letter series such as "MMMMM" or "NNMNN." Sometimes the middle letter was the same as the other four letters, and sometimes it wasn't. Moser says, "It's pretty simple, doing the same thing over and over, but the mind can't help it; it just kind of zones out from time to time." That's when people make mistakes—and they notice it immediately.

When a subject made an error, the researchers saw two quick signals on the EEG: an initial response that indicated something

had gone awry—Moser calls it the "'Oh, crap' response"—and a second signal that indicated the person was consciously aware of the error and was trying to figure out what went wrong. Both signals occurred within a quarter of a second of the mistake. After the experiment, the researchers asked the subjects if they believed they could learn from mistakes. Those who said yes turned out to be the ones for whom there was a larger second signal; it was as if their brains were saying, "I see that I've made a mistake, and I will learn from that error."

It is important to note that our mind-sets are malleable. Carol Dweck of the Stanford School of Education has done a tremendous amount of work on this topic and has shown how the messages that others tell us and that we tell ourselves dramatically influence how we see our place in the world. Compelling proof comes from a study by Dweck and Lisa Sorich Blackwell on low-achieving seventh graders. All of the students had a study skills workshop. Half of the group attended a general session on memory, while the other half learned that the brain, like a muscle, grows stronger through exercise. The group that was told that the brain is like a muscle showed much more motivation and had significantly improved grades in math, while the control group showed no improvement.[6] This study is supported by extensive research and demonstrates that your mind-set and attitude are within your own control.

No matter how much we improve our knowledge, imagination, and attitude, we are embedded in a world that has a huge influence on us. I remember clearly when my son, Josh, was four years old, and he had never seen commercial TV before, which meant that he had never seen a commercial. One day, to keep him safely

occupied while I took a shower, I turned on the TV and told Josh to come get me if there was any problem. Within two minutes Josh started shouting, "Mommy, Mommy, Mommy!" With soap running down my face, I quickly grabbed a towel and ran to see what was wrong. Josh exclaimed, "Mommy, we *have* to buy Pop-Tarts!" This story is a reminder that we are swimming in a cultural soup that profoundly influences our attitudes and our actions. No matter how much we try to control our environment, the outside world always leaks in and influences how we think, feel, and act.

There are three important factors in the outside world that contribute to your Innovation Engine: the resources in your environment, your local habitat, and the surrounding culture. These environmental factors can either stimulate or inhibit your creativity. Let's look at each of them more closely.

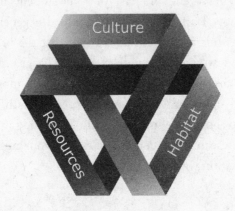

RESOURCES

Resources are all the things of value in your environment. They come in all different forms, including funds that can be invested

in new companies and natural resources such as fish, flowers, copper, diamonds, beaches, and waterfalls. They include individuals with knowledge and expertise who can serve as guides, role models, and mentors as well as organizations such as universities and local firms that foster innovation.

The more knowledge you have, the more resources you can mobilize. For example, the more you know about fishing, the more fish you can catch; the more you know about copper, the more you can mine; and the more you know about venture capital, the more likely you are to get funding. Of course, if you live somewhere with a lot of fish, you learn about fishing; if you live somewhere where there is an abundance of copper, you learn about mining; and if you live in a place with a wealth of venture capitalists, you learn about venture capital. As such, the resources in your environment influence your knowledge, and your knowledge allows you to access the resources. This is why resources are right outside knowledge in the Innovation Engine.

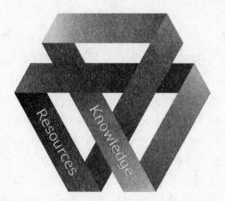

It is important to note that some of the resources in your environment are easy to spot, while others require physical or

mental mining. It is up to you to recognize the unique resources in your environment and to gain the knowledge to utilize them. Unfortunately, in some parts of the world people don't recognize the assets in their environment. They are so focused on trying to replicate the assets in other parts of the world that they don't see the value in their own resources.

For example, I was recently in northern Chile, which is one of the most magical places on earth. The country is essentially a tiny strip of land with a three-thousand-mile beach on one side and the magnificent Andes on the other. I was talking with local residents in Antofagasto and asked what was getting in the way of their economic prosperity. A man turned to me and said, "Our unattractive environment." I looked at him with surprise. Outside the window was a stunning view of the ocean. He literally didn't see the beauty and potential right in front of him.

HABITAT

Habitat is placed right outside Imagination on the Innovation Engine because the habitats we create are essentially an external manifestation of our imagination. We create physical spaces that reflect the way we think, and in turn, those habitats influence our imagination. As described in earlier chapters, we need to think carefully about the spaces we design, the incentives we put in place, the rules we enforce, the constraints we impose, and the people with whom we work, because each of these factors contributes to our ability to generate new ideas. Managers, educators, parents, and community leaders play a big role in creating habitats that foster imagination in their employees, students, and children. As discussed in prior chapters, small changes in the environment have a big influence on creative output.

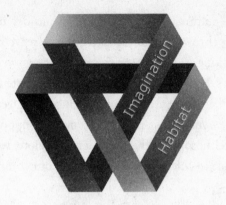

CULTURE

Culture captures the ways in which groups of people perceive, interpret, and understand the world around them. We are each extremely sensitive to our culture, including stories about local heroes, gossip about those who are doing things that don't fit the cultural norms, laws that determine what is considered acceptable behavior, and advertisements that directly tell us what to do. From the moment we wake up until the moment we go to sleep, we are immersed in a cultural stew that deeply influences our thoughts and actions. As we all know, someone who grows up in San Francisco is surrounded by a completely different culture from someone who grows up in suburban New Jersey, rural India, or downtown London. These cultures communicate directives that have a profound influence on how we think, what we believe, and how we act.

Each person, family, school, and organization contributes to the culture, and therefore the culture in any community is essentially the collective attitudes of all those who live there. This is why culture sits right outside attitude in the Innovation Engine. If even a small number of individuals change their attitude, then

the ambient culture naturally changes. Consider how cultural norms about throwing trash on the ground, recycling cans and bottles, smoking cigarettes, and saving energy have changed over the years. Each of these waves of change started when a few people modified their attitudes and behaviors. Over time these ideas became contagious and were eventually supported by laws that reinforce those collective attitudes. Therefore, we all have an important role in cultivating the culture in our communities.

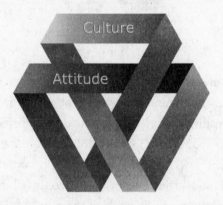

All the parts of your Innovation Engine are inexorably connected and deeply influence one another.

- Your *attitude* sparks your curiosity to acquire related *knowledge.*

- Your *knowledge* fuels your *imagination,* allowing you to generate innovative ideas.

- Your *imagination* catalyzes the creation of stimulating *habitats,* leveraging the *resources* in your environment.

- These *habitats,* along with your *attitude,* influence the *culture* in your community.

Below is the fully functional Innovation Engine, showing how all the parts are braided together. The inside of the engine is intertwined with the outside; and the factors on the inside and outside mirror each other. By engaging all the parts of this engine, creativity is unleashed, leading to transformative changes in individuals, teams, and organizations.

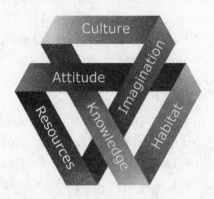

There are great examples of this type of transformation all over the world, where individual entrepreneurs draw upon their drive and imagination to create new hubs of innovation in unlikely places. Daniel Isenberg, of Babson College, describes this beautifully in "How to Start an Entrepreneurial Revolution":

> It has become clear in recent years that even one success can have a surprisingly stimulating effect on an entrepreneurial ecosystem—by igniting the imagination of the public and inspiring imitators. I call this effect the "law of small numbers." Skype's adoption by millions and eventual $2.6 billion sale to eBay reverberated throughout the small country of Estonia, encouraging highly trained technical people to start their own companies. In China,

Baidu's market share and worldwide recognition have inspired an entire generation of new entrepreneurs.[7]

Isenberg goes on to tell a wonderful story of a young man in Saudi Arabia, Abdulla Al-Munif, who broke through traditional expectations to launch a business making chocolate-covered dates, which he sold in kiosks inside other stores. His business, Anoosh, eventually grew into a national chain of stores, and Abdulla Al-Munif became a local hero, admired and then emulated by other young people in Saudi Arabia.

This philosophy is embraced by Endeavor, an organization with the goal of identifying and empowering high-potential entrepreneurs in the developing world. With branches throughout Latin America, the Middle East, and Africa, Endeavor successfully creates local role models in each region. These entrepreneurs, who boldly and creatively start ventures in their communities, become icons of success and change the landscape of what can be accomplished in each region. Essentially, as individuals, they change the entire culture in their communities, making them more open, accepting, and supportive of future innovators. The key, as Isenberg states, is to "foster homegrown solutions—ones based on the realities of their own circumstances, be they natural resources, geographic location, or culture."

There are several remarkable cases from Endeavor entrepreneurs.[8] For example, Wenceslao Casares (Wences), who was born in a remote part of Patagonia, along with Meyer Malka (Micky) from Caracas, Venezuela, decided to start the first online brokerage site in Argentina. The company, called Patagon, quickly expanded to serve all of Latin America and was ultimately purchased by Banco Santander in Spain. Wences and Micky become role models across Latin America as well as investors and men-

tors. As a result, dozens of companies have been started with their help, and hundreds have been inspired by their success. Their venture literally sparked an entrepreneurial revolution in the region, which has had far-reaching effects on the economy and quality of life for tens of thousands of people.[9]

This story is played out over and over again in other regions of the world. David Wachtel of Endeavor shared the story of Fadi Ghandour in Jordan, who founded a company called Aramex, a package-delivery business. This venture grew in size and became the first company in the Middle East to be traded on NASDAQ. Fadi became a local role model and investor and is active in promoting entrepreneurship as an Endeavor Jordan board member. He is helping to spark the evolution of many other ventures, including Maktoob, an Arab-language Internet portal that was sold to Yahoo. That sale led to another large pool of investors and mentors who, in turn, triggered the founding of additional ventures.

Many inspiring stories from Endeavor don't involve high-technology businesses. For example, in Egypt two sisters, Hind and Nadia Wassef, started a chain of bookstores in Cairo. Not only has their business thrived, but these stores have also become cultural centers within the community, creating an ecosystem for sharing ideas. And in South Africa, Cynthia Mkhomba started a contract cleaning business. She now employs nearly one thousand people and has helped them escape poverty. The important thing to keep in mind is that each of these ventures is a virtual engine for the creation of ideas that, in turn, spawn new ventures.

To give students the experience of seeing opportunities where others don't, at STVP we launched a Global Innovation Tour-

nament five years ago, in which students were given either five dollars or a simple object, such as a water bottle or a handful of rubber bands, and asked to create as much value as they could from these objects. The results of this project, described in detail in *What I Wish I Knew When I Was 20*,[10] point to the fact that everything, even a handful of rubber bands, can be turned into something of greater value. In fact, several of these weeklong projects turned into companies that have been growing for several years now.

I have received messages from people from around the world who have run the five-dollar project—changing the currency, but not the concept—including the United States, India, Korea, Kenya, Thailand, Canada, and Japan. For example, in Kenya, an organization named LivelyHoods, founded by Maria Springer, used this project to select homeless youth to participate in a new program designed to get them off the streets and into real jobs. LivelyHoods was created to help unemployed young people in the slums who barely survive by collecting plastic, washing cars, or turning to prostitution. Its goal is to create a way for these young people to earn a proper living.[11]

When candidates arrive at the LivelyHoods offices to apply for the program, the LivelyHoods team puts them into pairs and gives them two hours to earn as much as possible, starting with a tiny amount of money. In one instance, as soon as the teams started, rain began to pour down. One pair bought tomatoes and tried to resell them on the street corner, and another did the same with lollipops. However, a third team looked around and decided to use the rain to their advantage. Instead of using the money they had been given, they used the rain. They dashed to the water station on the outskirts of the town, where the women

go to fetch water for their families, and offered to carry the heavy ten-liter jugs. The women were delighted not to have to walk home with the large jug of water in the pouring rain and agreed to pay the equivalent of twelve cents for this service. The young men ran back and forth to the water station and returned to the LivelyHoods offices, sopping wet, at the end of two hours. They realized that the most valuable assets they had at that moment were the rain and their strength. By leveraging both of those, they created more value than their compatriots who were selling tomatoes or candy.

I just returned from Japan, where I gave an even more challenging assignment to a group of forty students at Osaka University. Instead of starting with something of small value, such as five dollars or a handful of rubber bands, I challenged the participants to create as much value as possible from the contents of a single trash can in only two hours. While there, I sent a note to several colleagues around the world and asked them to invite their students to participate as well. As a result, we had teams from Thailand, Korea, Ireland, Ecuador, and Taiwan taking part in this challenge at the same time.

At first the students thought this assignment was crazy. How could they create something from trash?! But this challenge prompted them to contemplate the meaning of "value." They spent hours discussing what value meant to each of them, coming up with such things as health, happiness, community, knowledge, and financial security. These insights led them to look at the contents of each trash can in a new light.

The results from this assignment were fascinating and remarkably diverse. One team from Japan took old hangers and plastic garment covers from a local dry cleaner and created mats

that can be used for sitting on damp grass on their campus. They painted game boards on the mats so that students can play with one another while they enjoy time together. A team from Ecuador created a beautiful sculpture of a bird using organic yard waste, and a team from Thailand made a spectacular carved elephant out of a used coconut shell. A team from Ireland turned a bunch of old socks into a fabulous sweater. And a team from Taiwan made a collection of toys for children using the contents of a single trash can. One of the participating students remarked afterward, "I had no idea that we are so creative!"

These interactive projects are designed to demonstrate that starting with essentially nothing, you can create remarkable innovations. In the trash-can challenge, the students used their own knowledge, imagination, and attitude to create something from nothing, and I provided the habitat, culture, and resources to stimulate that process. This is important. The students already had the innate skills they needed, but the habitat created by our classroom environment and the rules of the assignment triggered their motivation and unleashed their creativity. The Innovation Engine captures the relationship between all these factors:

- Your *knowledge* provides the fuel for your imagination.

- Your *imagination* is a catalyst for the transformation of knowledge into ideas.

- This process is influenced by a myriad of factors in your environment, including your *resources, habitat,* and *culture.*

- Your *attitude* is a powerful spark that sets the Innovation Engine in motion.

Essentially, creativity is an endless resource, initiated by your drive to tackle challenges and to seize opportunities. Anything and everything can spark your Innovation Engine—every word, every object, every decision, and every action. Creativity can be enhanced by honing your ability to observe and learn, by connecting and combining ideas, by reframing problems, and by moving beyond the first right answers. You can boost your creative output by building habitats that foster problem solving, crafting environments that support the generation of new ideas, building teams that are optimized for innovation, and contributing to a culture that encourages experimentation.

You hold the keys to your Innovation Engine and have creative genius waiting to be unleashed. By tapping into this natural resource, you have the power to overcome challenges and generate opportunities of all dimensions. Your ideas—big and small—are the critical starting point for innovations that propel us forward. Without creativity, you are trapped in a world that is not just stagnant, but one that slips backward. As such, we are each responsible for inventing the future. Turn the key.

ACKNOWLEDGMENTS

This book is the product of my own Innovation Engine, and without each of the components it would never have come to life. The project started with observation as I studied what was happening in my creativity course at Stanford University and in my work with students, faculty, and companies around the world. I increased my knowledge by conducting in-depth interviews with dozens of people who helped me expand my understanding of creativity.

I thank all of the following people for taking the time to talk with me and for sharing their stories and insights, including Alan Murray, Alistair Fee, Ann Miura-Ko, AnnaLee Saxenian, Arthur Benjamin, Brendan Boyle, David Friedberg, David Wachtel, Dennis Boyle, Diego Piacentini, Elise Bauer, Elizabeth Weil, Eric Ries, Ewan McIntosh, Forrest Glick, Freada Kapor Klein, Heidi Neck, James Plummer, Jean Boudeguer, Jeanne Gang, Jeff Hawkins, Jesse Cool, John Adler, Josh Makower, Julian Gorodsky, Kevin Systrom, Leticia Britos, Liz Gerber, Lonny Grafman, Lynn Tennefoss, Maria Springer, Mark Zdeblick, Matthew May, Meyer

Malka, Michael Barry, Michael Krieger, Michael White, Michele Barry, Mir Imran, Mitch Kapor, Nancy Isaac, Nicolas Shea, Patricia Ryan Madson, Paul Hudnut, Peggy Burke, Peter Diamandis, Randi Zuckerberg, Robert Siegel, Rodrigo Jordan, Rory McDonald, Sam Wineburg, Scott Doorley, Scott Summit, Shaun Young, Steve Blank, and Trip Adler.

This book also required a supportive *habitat*, which I am truly fortunate to have at Stanford University, specifically the Department of Management Science and Engineering and the Hasso Plattner Institute of Design. My terrific colleagues provide incredible encouragement for creative endeavors. Special thanks go to Angela Hayward, Bernie Roth, Bob Sutton, Charlotte Burgess Auburn, David Kelley, Forrest Glick, George Kembel, Jim Plummer, John Hennessy, Julian Gorodsky, Kathy Eisenhardt, Leticia Britos, Matt Harvey, Maureen Carroll, Michael Barry, Nicole Kahn, Nikkie Salgado, Peter Glynn, Rebecca Edwards, Sarah Stein Greenberg, Shilpa Thanawala, Steve Barley, Steve Blank, Susie Wise, Terry Winograd, and Tom Byers.

I also drew upon incredibly valuable *resources* in my environment, including my wonderful publisher, Mark Tauber, my inspiring editor, Gideon Weil, and the ever patient and talented production editor, Suzanne Quist. I also received valuable feedback and advice from reviewers who took the time to read an early draft of the manuscript, including Aaron Kalb, Allison Fink, Jerry Seelig, Josh Tennefoss, Leticia Britos, Lorraine Seelig, Michael Tennefoss, Moritz Sudof, and Steve Blank.

I took full advantage of the Silicon Valley *culture*, which reinforced my willingness to do endless experiments on the way to completing this book. I also drew great inspiration from those around me who have taken on projects much more challenging

than this one and have found ways to reach their goals. They served as great role models along the way.

All of these factors fueled my *imagination,* as I tried to find a way to bring order to the insights I had gained about creativity. In fact, it wasn't until I was done writing the first draft of this book that all the pieces started to fit together and the Innovation Engine began to take shape. At that time, I reframed the entire book, connected and combined the chapters, and challenged many of my original assumptions about creativity and innovation.

The entire project was driven by my desire to understand the creative process and to share my insights. I wanted to contribute something meaningful to the global conversation about innovation, based upon my years of experience in the classroom.

None of this could have happened without the amazing support of my wonderful husband, Michael, and our son, Josh. Both have listened to my ideas on creativity for years and have always engaged with enthusiasm. Their insights are baked into this book in endless ways.

Finally, this book is dedicated to one of my closest friends, Sylvine, who passed away while I was writing this book. For Sylvine, life was an endless opportunity to create meaning for herself and others. For thirty years she was my muse and mentor. I miss her dearly.

NOTES

INTRODUCTION

1. Sarah Lyall, "Oxford Tradition Comes to This: 'Death' (Expound)," *New York Times*, May 27, 2010.
2. Lyall, "Oxford Tradition Comes to This."
3. The Hasso Plattner Institute of Design at Stanford, also called the "d.school," is committed to teaching students about design thinking. You can find out more at dschool.stanford.edu.
4. The Stanford Technology Ventures Program is the hub for entrepreneurship at the Stanford University School of Engineering, centered in the Department of Management Science and Engineering. You can find out more at stvp.stanford.edu.
5. Charlie Rose interviewed Eric Kandel on his television program, discussing creativity and the brain. Watch the episode at www.charlierose .com/guest/view/210.
6. Charles Limb, "Inner Sparks," *Scientific American*, May 2011, pp. 84–87.
7. There were nine different Muses, each one responsible for a different form of expression, including several types of poetry, dance, music, history, comedy, tragedy, and astronomy. The word "museum" is derived from the word "muse" and was a place where the Muses were worshipped.
8. One of Shakespeare's sonnets laments, "Where art thou, Muse, that thou forget'st so long?" In another he expresses appreciation to his muse: "So oft have I invoked thee for my Muse / And found such fair assistance in my verse."

9. Allan Snyder, John Mitchell, Terry Bossomaier, and Gerry Pallier, "The Creativity Quotient: An Objective Scoring of Ideational Fluency," *Creativity Research Journal* 16, no. 4 (2004): 415–20.

CHAPTER 1: SPARK A REVOLUTION

1. For the *Powers of Ten* video, see www.powersof10.com/film.
2. You can watch the Joshua Bell video at www.youtube.com/watch?v=hnOPu0_YWhw.
3. Derek Sivers, "Weird, or Just Different?," ted.com/talks/lang/en/derek_sivers_weird_or_just_different.html.
4. Learn more about pop-up restaurants at popuprestaurants.com.
5. See "Tesco: Homeplus Subway Virtual Store" at www.youtube.com/watch?v=nJVoYsBym88.
6. You can find a lecture by Scott Summit at ecorner.stanford.edu.
7. Watch a video about the "Reading like a Historian" project at www.you tube.com/watch?v=wWz08mVUIt8.

CHAPTER 2: BRING IN THE BEES

1. John Cassidy and Brendan Boyle, *The Klutz Book of Inventions* (Palo Alto, CA: Klutz Press, 2010).
2. The caption of the first *New Yorker* cartoon with the monster at the dinner table is: "Kevin, ask your girlfriend to tell us about her holiday traditions." The caption for the second *New Yorker* cartoon with the businessmen and a hobby horse is: "We'll start you out here, then give you more responsibilities as you gain more experience."
3. Matthew E. May, "What Winning the *New Yorker* Caption Contest Taught Me About Creativity," June 24, 2011, matthewemay.com/2011/06/24/what-winning-the-new-yorker-caption-contest-taught-me-about-creativity.
4. Matt Ridley, "Humans: Why They Triumphed," *Wall Street Journal*, May 22, 2010.
5. AnnaLee Saxenian, *Regional Advantage: Culture and Competition in Silicon Valley and Route 128* (Cambridge, MA: Harvard University Press, 2006).
6. Steve Jobs, 1994, www.youtube.com/watch?v=CW0DUg63lqU.
7. "World's Coolest Office Competition," www.architizer.com/en_us/blog/dyn/31597/and-the-winners-are.
8. Sabin Russell, "Lizards Slow Lyme Disease in West," *San Francisco Chronicle*, April 17, 1998.
9. Adam Gorlick, "Is Crime a Virus or a Beast?" *Stanford Report*, February 23, 2011.

CHAPTER 3: BUILD, BUILD, BUILD, JUMP!

1. Tim Hurson, *Think Better: An Innovator's Guide to Productive Thinking* (New York: McGraw-Hill, 2007).

2. Genrich Altshuller, *Creativity as an Exact Science* (New York: Gordon and Breach, 1984).

3. Kevin Roebuck, *TRIZ: Theory of Inventive Problem Solving: High-Impact Strategies—What You Need to Know: Definitions, Adoptions, Impact, Benefits, Maturity, Vendors* (Richmond, VA: Tebbo, 2011).

4. Reena Jana, "The World According to TRIZ," *Bloomberg Businessweek,* May 31, 2006.

5. Alex Faickney Osborn, *Applied Imagination: Principles and Procedures of Creative Problem-Solving,* 3rd rev. ed. (New York: Scribner, 1963).

6. Tom Kelley, *The Art of Innovation: Lessons in Creativity from IDEO, America's Leading Design Firm* (New York: Currency, Doubleday, 2001).

7. For information about the National Center for Engineering Pathways to Innovation, see epicenter.stanford.edu.

CHAPTER 4: ARE YOU PAYING ATTENTION?

1. Richard Wiseman, "The Luck Factor," *Skeptical Inquirer,* May/June 2003.

2. David Foster Wallace, Commencement Address, Kenyon College, May 21, 2005.

3. You can find a lecture by Steve Blank at ecorner.stanford.edu.

4. A lecture by David Friedberg is available at ecorner.stanford.edu.

5. Jeff Hawkins with Sandra Blakeslee, *On Intelligence* (New York: Times Books, 2004).

6. Jerry Seinfeld's routine can be found at www.seinology.com/scripts/script-14.shtml.

7. Bob Siegel's extensive collection of photos from around the world can be seen at www.stanford.edu/~siegelr/photo.html.

8. Twyla Tharp, *The Creative Habit: Learn It and Use It for Life* (New York: Simon & Schuster, 2005).

9. An interview with Mir Imran is available at ecorner.stanford.edu.

CHAPTER 5: THE TABLE KINGDOM

1. Scott Doorley and Scott Witthoft, *Make Space: How to Set the Stage for Creative Collaboration* (Hoboken, NJ: Wiley, 2012).

2. R. S. Ulrich, "View Through a Window May Influence Recovery from Surgery," *Science* 224, no. 4647 (1984): 420–21.

3. Ori Brafman and Rom Brafman, *Click: The Forces Behind How We Fully Engage with People, Work, and Everything We Do* (New York:

Crown Business, 2010). You can watch a video of Ori Brafman's talk at Stanford at ecorner.stanford.edu.

4. Adrian North, "The Effect of Background Music on the Taste of Wine," *British Journal of Psychology,* September 7, 2011.

5. Ewan McIntosh, "Clicks & Bricks: When Digital, Learning, and Physical Space Meet," October 3, 2010, edu.blogs.com.

CHAPTER 6: THINK OF COCONUTS

1. You can find video clips of Marissa Mayer at ecorner.stanford.edu.

2. Teresa Amabile, Constance Hadley, and Steve Kramer, "Creativity Under the Gun," *Harvard Business Review,* August 2002.

3. You can find video clips of Stephanie Tilenius of eBay at ecorner .stanford.edu.

4. Eric Ries, *The Lean Startup: How Today's Entrepreneurs Use Continuous Innovation to Create Radically Successful Businesses* (New York: Crown Business, 2011). A lecture by Eric Ries is available at ecorner.stanford .edu.

5. Rachel Fershleiser and Larry Smith (eds.), *Not Quite What I Was Planning: Six-Word Memoirs by Writers Famous and Obscure, from* SMITH *magazine* (New York: HarperPerennial, 2008).

CHAPTER 7: MOVE THE CAT FOOD

1. Tom Chatfield, "7 Ways Games Reward the Brain," TED Talk, July 2010, www.TED.com/talks/tom_chatfield_7_ways_games_reward_the_ brain.html.

2. Joe Nocera, "Is This Our Future?" *New York Times Sunday Review,* June 25, 2011.

3. *Written? Kitten!,* writtenkitten.net; *Write or Die,* writeordie.com.

4. Robert Sutton, *Weird Ideas That Work: 11½ Practices for Promoting, Managing, and Sustaining Innovation* (New York: Free Press, 2002).

5. For the Fun Theory, see thefuntheory.com.

6. Ira Glass, "Two Steps Back," *This American Life,* www.thisamericanlife .org/radio-archives/episode/275/two-steps-back.

CHAPTER 8: MARSHMALLOW ON TOP

1. Edward de Bono, *Six Thinking Hats* (Boston: Little, Brown, 1985).

2. Malcolm Gladwell, "The Bakeoff," *New Yorker,* September 5, 2005.

3. Tom Wujec, "Build a Tower, Build a Team," TED Talk, February 2010, www.ted.com/talks/tom_wujec_build_a_tower.html.

4. Haygreeva Rao, Robert Sutton, and Allan P. Webb, "Innovation Lessons from Pixar: An Interview with Oscar-Winning Director Brad Bird," *McKinsey Quarterly,* April 2008.

5. Marcial Losada, "The Complex Dynamics of High-Performance Teams," *Mathematical and Computer Modelling* 30, no. 9–10 (1999): 179–92.

6. John Kounios and Mark Beeman, "The Aha! Moment: The Cognitive Neuroscience of Insight," *Current Directions in Psychological Science* 18, no. 4 (August 2009): 210–16.

CHAPTER 9: MOVE FAST—BREAK THINGS

1. Jonah Lehrer, "Every Child Is a Scientist," *Wired*, September 28, 2011, www.wired.com/wiredscience/2011/09/little-kids-are-natural-scientists.

2. Richard Maulsby, director of public affairs for the U.S. Patent & Trademark Office, quoted in Karen E. Klein, "Avoiding the Inventor's Lament," *Business Week*, November 10, 2005.

3. Paul Kedrosky, "Vinod Khosla on Failure: Take More Risk," *Seeking Alpha*, October 27, 2009, seekingalpha.com/article/169278-vinod-khosla-on-failure-take-more-risk.

4. I heard this story at the Carmel Authors and Ideas Festival in 2011, when Dave Barry and Ridley Pearson spoke about making the play based upon their book *Peter and the Starcatchers*.

5. "Gever Tully Teaches Life Lessons Through Tinkering," TED Talk, February 2009, www.ted.com/talks/gever_tulley_s_tinkering_school_in_action.html.

6. You can find video clips of Mir Imran at ecorner.stanford.edu.

7. Answers to the puzzles, from Heather Dickson, ed., *Brain-Boosting Lateral Thinking Puzzles* (Lagoon, 2000):

 • What can be seen in the middle of March and April that cannot be seen at the beginning or end of either month? *The letter* r.

 • Two men are lost in the woods. One starts walking north, and one starts walking south. In a quarter of an hour the two men bump into each other. How did that happen? *The two men did not go out together, but bumped into each other later.*

 • Two sisters have newborn babies who are exactly one hour old. One was born at night and one was born in the morning. How can this be? *One baby was born in Singapore at 8:00 P.M. and one was born in London at noon, since the cities are eight time zones apart.*

 • There are six eggs in the basket. Six people each take one of the eggs. How can it be that one egg is left in the basket? *One of the people takes the basket along with the last egg.*

8. PostSecret, www.postsecret.com.

9. Startup Weekend, startupweekend.org.

10. Sebastian Thrun, "What We're Driving At," googleblog.blogspot.com/2010/10/what-were-driving-at.html.

CHAPTER 10: IF ANYTHING CAN GO WRONG, FIX IT!

1. Start-Up Chile, www.startupchile.org.
2. Baba Shiv, "Why Failure Drives Innovation," *Stanford Graduate School of Business News*, March 2011, www.gsb.stanford.edu/news/research/ShivonFailureandInnovation.html.
3. You can find an interview with both John Adler and his son Trip at ecorner.stanford.edu.
4. Catherine Thimmesh, *Team Moon: How 400,000 People Landed Apollo 11 on the Moon* (New York: Houghton Mifflin, 2006).
5. Leigh Buchanan, "Finding Jobs for Ex-Offenders," *Inc.*, May 2011.

CHAPTER 11: INSIDE OUT AND OUTSIDE IN

1. Learn more about Elephant Nature Park at www.elephantnaturepark.org.
2. Mark Twain, *A Connecticut Yankee in King Arthur's Court*, 1889, chap. 34.
3. Karl K. Szpunar and Kathleen B. McDermott, "Episodic Future Thought: Remembering the Past to Imagine the Future," in K. D. Markman, W. M. P. Klein, and J. A. Suhr, eds., *Handbook of Imagination and Mental Stimulation* (New York: Psychology Press, 2008), pp. 119–29.
4. Patricia Ryan Madson, *Improv Wisdom: Don't Prepare, Just Show Up* (New York: Bell Tower, Crown, 2005).
5. Jason S. Moser, Hans S. Schroder, Carrie Heeter, Tim P. Moran, Yu-Hao Lee, "Mind Your Errors: Evidence for a Neural Mechanism Linking Growth Mind-set to Adaptive Posterror Adjustments," *Psychological Science* (forthcoming).
6. Marina Krakovsky, "The Effort Effect," *Stanford Magazine*, March/April 2007.
7. Daniel Isenberg, "How to Start an Entrepreneurial Revolution," *Harvard Business Review*, June 2010.
8. Learn more about Endeavor at www.endeavor.org.
9. You can find a lecture by Wences Casares and Meyer Malka at ecorner.stanford.edu.
10. Tina Seelig, *What I Wish I Knew When I Was 20* (San Francisco: Harper One, 2009).
11. Learn more about LivelyHoods at livelyhoods.org.

INDEX